Andreas Ornithoparcus His Micrologus Or Introduction: Containing The Art Of Singing

Andreas Ornithoparchus

ANDREAS

ORNITHOPARCVS

HIS *MICROLOGVS,*

OR

INTRODVCTION:

Containing the Art of *Singing.*

Digested into Foure Bookes.

NOT ONELY PROFITABLE, BVT also neceſſary for all that are ſtudious *of Muſicke.*

*ALSO THE DIMENSION AND PER-*ſect *Vſe* of the MONOCHORD, *according to* Guido Aretinus.

BY *IOHN DOVLAND* LVTENIST, Lute-player, and Bachelor of *Muſicke* in both *the Vniuerſities.*

1609

LONDON:
Printed for *Thomas Adams*, dwelling in *Paules* Church-yard, at the Signe of the white Lion.

TO THE RIGHT HONO-
RABLE *ROBERT* EARLE OF

Salisbury, Viſcount *Cranborne*, Baron of *Eſſingdon*,
Lord High *Treaſurer* of *England*, Principall *Secretarie* to the Kings moſt
excellent Maieſtie, Maiſter of the Courts of Wards and Liueries,
Chancellor of the moſt famous Vniuerſitie of Cambridge, *Knight*
of the moſt Noble Order of the Garter, and one of his *Maieſtie:*
moſt honourable Priuie Counſell.

*Our high Place, your princely Honours and Ver-
tues, the hereditary vigilance and wiſedome, wher-
with* Hercules-*like, you aſſiſt the protection of the
whole State : Though theſe (moſt honoured Lord)
are powerfull encitements to draw all ſorts to the
deſire of your moſt Noble protection. Yet beſides all
theſe (in more particular by your Lordſhip's ſpeciall Fauors and Gra-
ces) am I emboldened to preſent this Father of Muſicke* Ornithopar-
*chus to your worthyeſt Patronage, whoſe approoued Workes in my tra-
uailes (for the common good of our Muſitians) I haue reduced into our
Engliſh Language. Beſeeching your Lordſhip (as a chiefe Author of all
our good) graciouſly to receiue this poore preſentment, whereby your
Lordſhip ſhall encourage me to a future taſke, more new in ſubiect, and
as memorable in worth. Euery Plant brings forth his like, and of Mu-
ſitians, Muſicke is the fruit. Moreouer ſuch is your diuine Diſpoſi-
tion that both you excellently vnderſtand, and royally entertaine the
Exerciſe of Muſicke, which mind-tempering Art, the graue* Luther
*was not affraid to place in the next ſeat to Diuinity. My daily prayers
(which are a poore mans beſt wealth) ſhall humbly ſollicite the Author
of all Harmonie for a continuall encreaſe of your Honors preſent happi-
neſſe with long life, and a ſucceſſiue bleſſing to your generous poſteritie.*

Your Lordſhips humbly deuoted

Iohn Douland.

To the Reader.

Xcellent men haue at all times in all Arts deliuered to Posteritie their obseruations, thereby bringing Arts to a certainty and perfection. Among which there is no Writer more worthy in the Art of *Musicke*, than this Author *Ornithoparcus*, whose Worke, as I haue made it familiar to all that speake our Language, so I could wish that the rest in this kinde were by the like meanes drawne into our knowledge, since (I am assured) that there is nothing can more aduance the apprehension of *Musicke*, than the reading of such Writers as haue both skilfully and diligently set downe the precepts thereof. My industry and on-set herein if you friendly accept (being now returned home to remaine) shall encourage me shortly to diuulge a more peculiar worke of mine owne: namely, *My Obseruations and Directions concerning the Art of Lute-playing*: which Instrument as of all that are portable, is, and euer hath been most in request, so is it the hardest to mannage with cunning and order, with the true nature of fingering; which skill hath as yet by no Writer been rightly expressed: what by my endeuours may therein be attained, I leaue to your future Iudgement, when time shall produce that which is already almost ready for the Haruest. *Vale*, From my house in Fetter-lane this tenth of Aprill. 1609.

Your Friend,

Iohn Douland.

TO THE RIGHT HONO-
RABLE, WORTHY, AND WISE
GOVERNOVRS OF THE STATE OF *LVNENBVRG,*
ANDREAS ORNITHOPARCHVS OF *METNING,*
MAISTER OF THE LIBERALL SCIENCES.

E *read, that* Socrates *(hee that was by* Apollos *Oracle famoused for the wisest man in the world) was wont to say, That it had been fit mens hearts, should haue windowes, that so the thoghts might be discerned. This power if we now had, honourable Lords, beleeue it, you should discern my loue towards you and yours. But because speech is the mindes interpretour, and you cannot know men, and their thoughts, but by their words or writing, I am to intreat that you would take in as good part these words, which in my absence I vtter, as if I had in presence deliuered them.*

It is not out of any humor of arrogancy or vain ostentation that I do this : but that vpright, gentle, and religious fashion of yours, wherin you excell more than any Easterlings that border these Baltick coasts, these make me assay the art of Harmony, which the Grecians call Musicke ; Musicke the nurse of Christian Religion, and mother of good fashions, of honesty, of Common-wealths, if in any thing we may giue credite to the ancients.

These made me commit my sayles to the furious windes ; these made me giue Zoiles *and* Thersites *power to rage ouer me ; these made me trauell many Countreys not without endamaging my estate, to search out the* Art *; these made me many a time to sustaine wearinesse, when I might haue been at rest ; greefe, when I might haue solaced my selfe ; disgrace, when I might haue liued in good reputation ; pouertie, when I might haue liued in plenty. But also these things (right Worthies) seemed to me not worthy the regarding, when I sought how I might whilest others slept, whom your state doth nourish (before all others) prefire your youth, and so consequently the youth of all Germany, drawing them to good fashions, recalling them by the honest delights of Musicke from vnlawfull attempts, and so by little and little stirre them vp to vertuous actions. For* Socrates, *and* Plato, *and all the Pythagoreans did generally enact, that young men and maides should be trayned vp in Musicke, not to the end their mindes might be incited to wantonnesse by those baubles, which make Art to be so vilely*

B reputed

reputed of: but that the motions of the minde might be ruled and gouerned by law and reason. For seeing the nature of young men is vnquiet, and in all things desiring delights, & therfore refuseth seuerer arts, it is by the honest delights of Musick brought to those recreations, which may also solace honest old age.

Among those things wherwith the mind of man is wont to be delighted, I can finde nothing that is more great, more healthfull, more honest, than Musicke: The power wherof is so great, that it refuseth neither any sexe, nor any age, and (as Macrobius a man of most hidden & profound learning saith) there is no brest so sauage and cruell, which is not moued with the touch of this delight. For it doth driue away cares, perswade men to gentlenesse, represseth and stirreth anger, nourisheth arts, encreaseth concord, inflameth heroicall minds to gallant attempts, curbeth vice, breedeth vertues, and nurseth them when they are borne, composeth men to good fashion. For among all those things which doe admit sence, that onely worketh vpon the manners of men, which toucheth his eares, as Aristotle in his musicall problemes doth more at large discourse. Hence was it that Agamemnon being to goe Generall for the Troian warres, as Philelphus reports, left a Musitian at his house, who by singing the prayses of womens vertues might incite Clytemnestra to a chaste and honest life, wherein he did so farre preuaile, that the, say she could not be ouercome by Egistus his vnchaste attempts, till the vngodly wretch had made away the Musitian, who onely hindred him from his wicked purpose. Besides Lycurgus, though otherwise he enacted most seuere lawes for the Lacedæmonians his countrey-men; yet did he very much embrace Musicke, as Quintilian writes. I omit those ancient Philosophers, (for so they rather chose to be called, than to be named wise men) who did repose the summe of their studies in this art as in a certaine Treasure-house. I omit those princes who for the admirable sweetnesse of this art spend many talents. Lastly, I omit the most religious of al men, who though they estrange themselues from al worldly pleasure, yet dwell vpon this delight, as if it were the onely heauenly one. Since therfore this Art is both holy, and sweet, and heauenly, participating of a diuine, faire, end blessed nature, I thought good to dedicate this booke, wherein all the knots of practicke Musicke are vntied, to the gentle youth of your Citie, after it had been first brought forth at Rostoch, that famous Vniuersity of the Baltick coast, and since amended by the censure of the Elders, and publikely read in three famous Vniuersities of Germanie, the Vniuersitie of Tubyng, Heydelberg, and Maguntium. That by their deserts the after ages being helped, might pay the tribute of thanks not to me, but to them, as to the first mouing causes.

Wherefore wise Fathers, I beseech your wisedomes to deigne this booke your gentle fauour and acceptance, not contemning the base stile or little volume of that which is rather holy than pleasant, and set out not vpon any rash humour, but vpon a true deuotion. For it is written for them that fast, not for them that are filled with delicacies, though euen they may find here that which will fit their stomackes. And since great things fit great men, small things small men, I acknowledge my selfe small; and therefore giue small gifts, yet promise greater whensoeuer I shall grow greater. Farewell most happy, most worthy, most wise.

The

The Preface vpon the Diuision of the Worke.

 Eeing it is fitter, as an Emperour faid, to caſt out a few fit things, then to be burdened with many vnneceſſary fuperfluities, which precept *Horace* put him in minde of, ſaying :

Quicquid precipies eſto breuis, vt citò dicta,
Percipiant animi dolices, teneantq́, fideles.

What ere thou teach, be ſhort : the learners braine
Breeſe ſawes will quicker take, and beſt retaine.

Hence it is, that we haue reſolued to collect into certaine moſt ſhort rules, the precepts of Actiue Muſicke, if not all, yet the eſpeciall, out of diuers Authours. For to know all things and faile in nothing, is a mark rather of diuine then of humane nature. Now thoſe, whom I herein followed as my leaders, and acknowledge as my ſpeciall Patrons, are theſe :

For Theoricks		For Practicks	
Boëtius Romanus.		Guido Aretinus.	
Plutarchus Cheronæus.		Ioannes pontifex Ro.	
Saint Auguſtine.		Saint Bernard.	
Franchinus Gafforus.		Saint Gregorie.	
Valla Placentinus.		Berno the Abbot.	
Faber Stapulenſis.		Ioannes Tinctoris.	

Wherefore omitting all needleſſe circumlocutions, and affecting ſhortneſſe, the mother of truth, wee purpoſe to open all Practick Muſick in foure Bookes, for of ſo many parts it doth conſiſt. The firſt whereof, ſhall ſhew the principles of plaine Song: The next Meaſurall Song: The third the Accent: The fourth and laſt the Counterpoint, as it were the gouernour and mother of the reſt. The head of each Booke, ſhall in their places be mentioned, as occaſion ſhall ſerue.

B 2 THE

THE FIRST BOOKE OF
ORNITHOPARCHVS HIS
Muſicke, declaring the Principals of
plaine Song.

THE FIRST CHAPTER.
Of the Definition, Diuiſion, Profit, and Inuentors of Muſicke.

Eing to deliuer the Art of ſinging, than which in the
world there is nothing ſweeter, leſt out of a ſmall
errour a great may ariſe, let vs begin with the defi-
nition, by which the nature of all things is knowne :
that is with the eaſieſt things firſt, that ſo the Art may
be more fitly deliuered. And then, hauing vnfolded
the nature thereof in generall, wee will proceede to
the perticulars, firſt making the generall diuiſion,
and afterward handling each part ſeuerally.

The generall Deſcription of Muſicke.

Mvſicke(as *Franchinus Gafforus* in the third Chapter of the firſt booke
of *Theorie* writeth) is a knowledge of *Tuning,* which conſiſts in *ſound*
and *Song.* In *ſound* (I ſay) becauſe of the muſicke which the motion of the
cœleſtiall Orbes doth make. In *Song,* leaſt that melody which our ſelues pra-
ctiſe, ſhould be ſecluded out of our definition.

The Diuiſion of Muſicke.

Boëtius (to whom among the Latine writers of Muſicke, the praiſe is to
be giuen) doth ſhew in the ſecond Chapter of his firſt booke of Mu-
ſicke, that Muſicke is three-fold. The *Worlds Muſicke : Humane Muſicke :* and
Inſtrumentall Muſicke.

Of the Muſicke of the World.

VVHen God (whom *Plutarch* prooues to haue made all things to a
certaine harmonie) had deuiſed to make this world moueable, it
was

was neceffary, that he fhould gouerne it by fome actiue and moouing power; for no bodies but thofe which haue a foule, can moue themfelues, as *Franchinus* in the firft Chapter of his firft booke of *Theorie* faith. Now that motion (becaufe it is the fwifteft of all other, and moft regular) is not without found: for it muft needs be that a found be made of the very wheeling of the Orbes, as *Macrobius in Somnium Scip. lib.2.* writeth. The like fayd *Boëtius*, how can this quick-mouing frame of the world whirle about with a dumb and filent motion? From this turning of the heauen, there cannot be remoued a certaine order of Harmonie. And nature will (faith that prince of Romane eloquence *Cicero*, in his fixt booke *de Reipub.*) that extremities muft needs found deepe on the one fide, & fharp on the other. So then, the worlds Muficke is an Harmonie, caufed by the motion of the ftarres, and violence of the Spheares. *Lodouicus Cælius Rodiginus; lectionum antiquarum lib.5. cap.25.* writeth, That this Harmony hath been obferued out of the confent of the heauens, the knitting together of the elements, and the varietie of times. Wherefore well fayd *Dorilus* the Philofopher, That the World is Gods Organe. Now the caufe wee cannot heare this found according to *Pliny* is, becaufe the greatnefs of the found doth exceede the fence of our eares. But whether wee admit this Harmonicall found of the Heauens, or no, it skils not much; fith certaine it is, that the grand Work-maifter of this *Mundane Fabricke*, made all things in number, weight, and meafure, wherein principally, *Mundane Muficke* doth confift.

Of Humane Muficke.

HVmane Muficke, is the Concordance of diuers elements in one compound, by which the fpirituall nature is ioyned with the body, and the reafonable part is coupled in concord with the vnreafonable, which proceedes from the vniting of the body and the foule. For that amitie, by which the body is ioyned vnto the foule, is not tyed with bodily bands, but vertuall, caufed by the proportion of humors. For what (faith *Cælius*) makes the powers of the foule fo fundry and difagreeing to confpire oftentimes each with other? who reconciles the Elements of the body? what other power doth foder and glue that fpirituall ftrength, which is indued with an intellect to a mortall and earthly frame, than that Muficke which euery man that defcends into himfelfe finds in himfelfe? For euery like is preferued by his like, and by his diflike is difturbed. Hence is it, that we loath and abhorre difcords, and are delighted when we heare harmonicall concords, becaufe we know there is in our felues the like concord.

Of Inftrumentall Muficke.

INftrumentall Muficke, is an Harmony which is made by helpe of *Inftruments*. And becaufe Inftruments are either artificiall, or naturall, there is

one

one sort of Muficke, which is made with artificiall Inftruments; another, which is made with naturall inftruments. The Philofophers call the one *Harmonicall*; the other *Organicall.*

Of Organicall Muficke.

ORganicall Muficke (as *Cœlius* writeth) is that which belongeth to artificiall Inftruments: or it is a fkill of making an *Harmony* with beating, with fingring, with blowing: with beating, as Drums, Tabors, and the like: with blowing, as Organs, Trumpets, Fluits, Cornets: with fingring, as thofe Inftruments which are commanded, either with the touching of the fingers, or articulating of the Keyes. Yet fuch Inftruments as are too voluptuous, are by *Cœlius Rodiginus* reiected.

Of Harmonicall Muficke.

HArmonicall Muficke, is a faculty weighing the differences of high and low founds by fence and reafon, *Boetius*: Or, it is a cunning, bringing forth the founds with Humane voyce, by the helpe of naturall Inftruments, and iudging all the Sounds which are fo brought forth. This as *Placentinus* writeth in the third Chapter of the fecond booke of his Muficke: is two-fold, *Infpectiue* and *Actiue.*

Of Infpectiue Muficke.

INfpectiue Muficke, is a knowledge cenfuring and pondering the Sounds formed with naturall inftruments, not by the eares, whofe iudgement is dull, but by wit and reafon.

Of Actiue Muficke.

ACtiue Muficke, which alfo they call *Practick*, is (as Saint *Auftine* in the firft booke of his Muficke writeth) the knowledge of finging well: or according to *Guido* in the beginning of his *Doctrinall*, it is a liberall Science, difpenfing the principles of finging truely. *Franchinus* (in the third Chapter of his firft Booke of his *Theorick*) doth fo define it: It is a knowledge of perfect finging, confifting of *founds, words,* and *numbers*; which is in like fort two-fold, *Menfurall,* and *Plaine.*

Of Menfurall Muficke.

MEnfurall Muficke, is the diuers quantitie of Notes, and the inequalitie of figures. Becaufe they are augmented or diminifhed according

as

as the *moode*, *time*, and *prolation* doth require: of this wee will speake at large in the second Booke.

Of Plaine Musicke.

P Laine *Musicke*, (as Saint *Bernard* an excellent searcher into regular and true Concinence) doth write in the beginning of his Musicke, saying: It is a rule determining the nature and forme of regular Songs. Their nature consists in the disposition, their forme in the progression and composition. Or plaine Musicke is a simple and vniforme prolation of Notes, which can neither be augmented nor diminished.

Of the Profitablenesse of this Art.

T He *Profit* of this Art is so great, (as writeth Pope *Iohn* the 22. of that name, in the second Chapter of his Musick) that whosoeuer giues himselfe to it, shall iudge of the qualitie of any Song, whether it be *triuiall*, or *curious*, or *false* : He knowes both how to correct that which is faulty, and how to compose a new one. It is therefore (saith he) no small praise, no little profit, no such labour as to be esteemed of slightly, which makes the Artist both a *Iudge* of those *Songs* which be composed, and a *Corrector* of those which be false, and an *Inuentor* of new.

Of the difference betwixt a Musitian and a Singer.

O F them that professe the Art of *Harmony*, there be three kindes; (saith *Franchinus* in the first Book the 4.chap. of his *Theoric*) one is that which dealeth with Instruments; the other maketh Verses; the third doth iudge the workes both of the instruments, and of the verses. Now the first, which dealeth with Instruments, doth herein spend all his worke; as *Harpers*, and *Organists*, & all others which approue their skil by Instruments. For they are remoued from the intellectuall part of Musicke, being but as seruants, and vsing no reason : voide of all speculation, and following their sence onely. Now though they seeme to doe many things learnedly and skilfully, yet is it plaine that they haue not knowledge, because they comprehend not the thing they professe, in the purenesse of their vnderstanding; and therefore doe we deny them to haue Musicke, which is the Science of making melodie. For there is knowledge without practise, and most an end greater, than in them that are excellent Practitioners. For we attribute the nimblenesse of fingring not to Science, which is only residing in the soule, but to practise, for if it were otherwise, euery man the more skilfull he were in the Art, the more swift he would be in his fingring. Yet doe we not deny the knowledge of Musicke to all that play on Instruments; for the Organist, and he that sings to the Harpe, may haue the knowledge of Musick,

which

which if it be, we account such the best Artists.

The second kind is of *Poets*, who are led to the making of a verse, rather by a naturall instinct, than by speculation. These *Boëtius* secludes from the speculation of Musicke, but *Austin* doth not.

The third kind of Musitians, be they which doe assume vnto them the cunning to iudge and discerne good *Ayres* from bad : which kind, (sith it is wholy placed in speculation and reason) it doth properly belong to the Art of *Musicke.*

Who is truely to be called a Musitian.

THerefore he is truely to be called a *Musitian,* who hath the faculty of speculation and reason, not he that hath only a practick fashion of singing : for so saith *Boëtius lib.1.cap.35.* He is called a Musitian, which taketh vpon him the knowledge of Singing by weighing it with reason, not with the seruile exercise of practise, but the commanding power of speculation, and wanteth neither speculation nor practise. Wherefore that practise is fit for a learned man : *Plutarch* in his Musicke sets downe (being forced vnto it by *Homers* authoritie) and proues it thus : *Speculation breedeth onely knowledge, but practise bringeth the same to worke .*

Who be called Singers.

THe *Practitioner* of this facultie is called a *Cantor,* who doth pronounce and sing those things, which the Musitian by a rule of reason doth set downe. So that the *Harmony* is nothing worth, if the *Cantor* seeke to vtter it without the Rules of reason, and vnlesse he comprehend that which he pronounceth in the puritie of his vnderstanding. Therefore well saith *Ioan. Papa 22. cap.2.* To whom shall I compare a *Cantor* better than to a *Drunkard*(which indeed goeth home,)but by which path he cannot tell. A *Musitian* to a *Cantor,* is as a *Prætor* to a *Cryer* : which is proued by this sentence of *Guido* :

> *Musicorum, ac Cantorum, magna est distantia,*
> *Isti sciunt, illi dicunt, quæ componit Musica,*
> *Nam qui facit, quod non sapit, diffinitur bestia*
> *Verum si tonantis vocis laudent acumina,*
> *Superabit* Philomela, *vel vocalis Asina.*

> Twixt *Musitians,* and *Practitians,* oddes is great :
> They doe know, these but show, what Art doth treat.
> Who doeth ought, yet knoweth nought, is brute by kind :
> If voices shrill, voide of skill, may honour finde?
> Then *Philomel,* must beare the bell,
> And *Balaams* Asse, Musitian was.

Therefore

Therefore a *Speculatiue Mufitian*, excels the *Practick*: for it is much better to know what a man doth, than to doe that which another man doth. Hence is it, that buildings and triumphs are attributed to them, who had the command and rule; not to them by whose worke and labour they were performed. Therefore there is great difference in calling one a Mufitian, or a Cantor. For *Quintilian* faith, That Mufitians were fo honoured amongft men famous for wifedome, that the fame men were accounted *Mufitians* and *Prophets*, and *wife men*. But *Guido* compareth thofe *Cantors*, (which haue made curtefie a farre off to Muficke) to brute Beafts.

Of the Inuentors of Muficke.

THe beft writers witneffe, That Muficke is moft ancient: For *Orpheus* and *Linus* (both borne of Gods) were famous in it. The inuention of it is attributed to diuers men, both becaufe the great antiquitie of it, makes the Author incertaine; and alfo becaufe the dignitie of the thing is fuch, and maketh fo many great men in loue with it, that euery one (if it were poffible) would be accounted the Authors of it. VVherefore fome thinke *Linus* the Thebane; fome, that *Orpheus* the Thracian; fome, that *Amphion* the Dircean; fome, that *Pythagoras* the Samian found out this Art. *Eufebius* attributes it to *Dionyfius, Diodorus*, to *Mercury, Polybius*, to the Elders of *Arcadia*, with whom there was fuch eftimation of Muficke, that it was the greateft difgrace that could be in that place to confeffe the ignorance of Muficke. Neither did they this, faith *Cælius lib. 5. antiquarum lectio*. for wantonneffe or delicateneffe, but that they might mollifie and temper their dayly labours, and befides their aufteritie and feuere fafhions, which befell them by a certaine fad temperature of the clyme with this fweetneffe and gentleneffe. Yet if we giue any credit to *Iofephus*, and the holy VVrit, *Tubal* the Sonne of *Lamech* was the chiefe and moft ancient Inuentor of it, and left it written in two tables, one of Slate; another of Marble before the flood for the pofteritie. The Marble one (fome fay) is yet in *Syria*. But leaft fome errour arife out of the multitude of thefe Inuentors, it is cleere that *Tubal* before the flood, that *Mofes* among the Hebrewes, that *Orpheus, Amphion*, and fuch like among the Gentiles, that *Pythagoras* among the Græcians, that *Boëtius* among the Latines, was firft famous for Muficke.

THE SECOND CHAPTER.

Of Voyces.

Oncord, (which rules all the Harmony of Muficke) cannot be without a *Voyce*, nor a *Voyce* without a *Sound*, faith *Boëtius, lib. 1. cap. 3.* VVherefore in feeking out the defcription of a *Voyce*, we thought fit to fearch out this point, what *Sounds* are properly called *Voyces*. Note therefore, that the found

of

of a fenfible creature is properly called a *Voyce*, for things without fence haue no *Voyce*, as *Cælius* writes, *antiquar. lect. lib.10. cap.53.* When we call pipes *Vocal*, it is a tranflated word, and a *Catachrefis*. Neither haue al fenfible cretures a *Voyce*: for thofe which want blood, vtter no *Voice*. Neither do fifhes vtter any *Voyce*, becaufe a *Voyce* is the motion of the ayre, but they receiue no ayre. Wherefore onely a fenfible creature doth vtter a *Voyce*, yet not all fenfible creatures, nor with euery part of their bodies (for the hands being ftroken together make a clapping, not a *Voyce*.) A *Voyce* therefore is a found vttered from the mouth of a perfect creature, either by aduife, or fignifi-cation. By aduife, (I fay) becaufe of the coffe, which is no *Voyce* : By figni-fication, becaufe of the grinding of the teeth. But becaufe this defcription of a *Voyce*, doth agree onely to a liuely *Voyce*, and not to a deafe muficall *Voyce*, which efpecially, being a fole fyllable is deafe, vnleffe it be actually expreffed, we muft find out another defcription more agreeable to it. There-fore a muficall *Voyce*, is a certaine fyllable expreffing a tenor of the Notes. Now Notes is that by which the highnes, or lownes of a Song is expreffed.

Who firft found out the Muficall Voyces.

B Eing that al Harmony is perfected by *Voyces*, and *Voyces* cannot be writ-ten, but remembred: (as *Gafforus lib.5. Theor. cap. 6.* and *1. Pract. cap.2.* faith; that they might therefore be kept the better in memory, *Guido Aretinus* a Monke, led by a diuine infpiration, deuoutly examining the Hymne of Saint *Iohn Baptift*, marked, that the fixe capitall fyllables of the Verfes, viz. *Vt, Re, Mi, Fa, Sol, La*, did agree with muficall Concords. Where-fore he applyed them in the chords of his introductory: which deuife *Ioannes* the 22. Bifhop of Rome allowed.

Of the Diuifion of Voyces.

I N the Fourth part of this Worke, I will handle that Diuifion, by which *Voyces* are diuided into *Vnifones, aquifones, Confones, Eumeles, &c.* Here I will onely touch that which will ferue our turne; Therefore of *Voyces*,

Some are called { b *Mols* / *Naturals* / ♮ *Sharps* } Viz. { *Vt Fa* / *Re Sol* / *Mi La* } becaufe they make a { *Flat* / *Meane* / *Sharpe* } found.

Befides of *Voyces* fome be Superiours : *viz. Fa, Sol, La*. Others be Inferi-ours: as *Vt, Re, Mi*.

Rules for the Voyces.

F Irft, *Vt*, (in *Harmonicall Songs*) is the head and beginning of the other Voyces.

The

The second, The Superiour Voyces are fitly pronounced in *Descending*, and the Inferiour in *Ascending*. Yet to this Rule there be Foure places contrary.

The first is this. In *F faut* you neuer sing *vt*, vnlesse you must sing *fa*, in *b fa ♮ mi*.

The second, In *b fa ♮ mi*, you must alwayes sing that Voice which the Scale requires.

The third, The same Voyce may not be repeated in *seconds*, though in *fourths, fifths*, and *eights* it may very fitly.

The fourth, Neither must the superiour Notes be sung in the *descending*, nor the inferiour Notes in the *ascending*, because they make a needlesse change.

A Progression of the Six Musicall Voyces according to the Rule of Arsim *and* Thesim.

The Third Chapter.

Of the Keyes.

He Wisedome of the Latine Musitians, imitating the diligence of the Græcians (whereas before the Singers did mark their Chords with most hard signes) did first note a musicall Introduction with Letters. To this *Guido Aretinus* ioyned those Voices he found out, and did first order the Musicall *Keyes* by lines and spaces, as appeareth in his Introductory. Therefore a *Key* is a thing compacted of a Letter and a Voyce. For the beginning of euery *Key* is a Letter, and the end a Syllable: Of a Voice (I say) not of Voyces, both because all the Keyes haue not many Voyces, and also because the names of *Generalities*, of *Specialties*, and of *Differences*, of which a definition doth consist, cannot be expressed in the plurall number. For *Animal* is the *genus*, not *Animalia*; a *Man* is the *species*, not men: *rationale* is the *difference*, not *rationabilia*: Or more formally, A *Key* is the opening of a Song, because like as a *Key* opens a dore, so doth it the Song.

Of the Number and Difference of Keyes.

Keyes, (as *Franchinus lib. 1. pract. cap. 1. doth write*) are 22. in number. Though Pope *Iohn*, and *Guido* (whom hee in his Fift Chapter saith to haue been the most excellent Musitians after *Boëtius*) onely make 20. These

Two and Twentie *Keyes* are comprehended in a three-fold order. The first
is of Capitall Letters; the Second of small; the Third of double Letters.
And all these *Keyes* differ one from the other in *sight*, *writing*, and *naming*:
because one is otherwise placed, written, or named than the other. Of the
Capitall there be eight, *viz.* Γ. A. B. C. D. E. F. G. Of the small also Eight,
a. b. c. d. e. f. g. for *b fa* ♮ *mi.* is not one *Key* onely, but two: which is prou-
ed by *mutations, voyces,* and *instruments*. The same you must account of
the vpper *bb fa* ♮ ♮ *mi* his Eight: of the double ones there be Six, *viz. aa. bb.*
♮ ♮ *cc. dd.* and *ee.* The order of all these is expressed in Ten lines and spaces
in the Table following.

Here followes the Introductorie of *Guido Aretinus* a Benedictine Monke,
a most wittie Musitian, who onely (after *Boëtius* did giue light to Musicke)
found out the *voyces,* ordered the *keyes,* and by a certaine diuine indu-
stry, inuented a most easie way of practise, as here followeth to be seene.

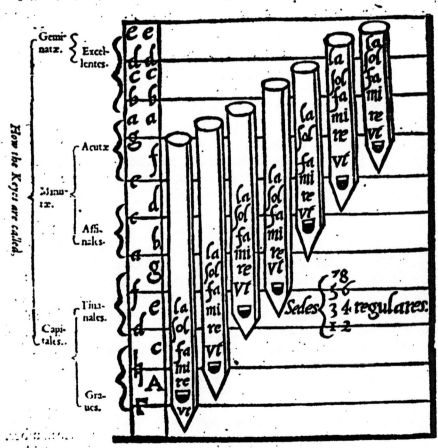

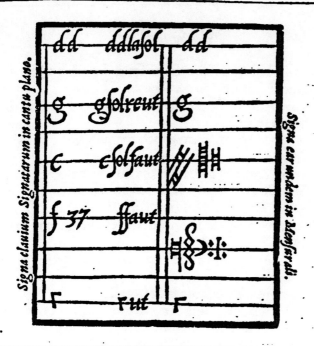

Of the Keyes which are to be marked.

OF *Keyes* some are to be marked, or (as others call them) *marked Keyes*, others are called *vnmarked Keyes*. Of the marked, there are fiue principall, *viz.* г *vt*, *F faut*, *C fol faut*, *G fol reut*, and *Dd la fol:* which the Ambrofians (as *Franch. lib. 1. praɛt. cap. 3.* reports) did mark with colours. *F faut*, with red, *C fol faut* with blew, double *bb* with skie-colour. But the Gregorians (whom the Church of Rome doth imitate) marking all the lines with one colour, to defcribe each of the marked *Keyes* by his firft Letter, or fome other figne, as in the Scale was mentioned.

Thofe *Keyes* which are leffe principall, are two, *b* round, and ♮ fquare: The firft fhews that the Voyce is to be fung *fa*, the fecond that it is to be fung *mi* in the place wherein it is found. And vnleffe one doe heedily difcerne *b* from ♮, he doth confound the Song (as *Berno* fayth) euen as wine and water being mingled together, one can difcerne neither.

To the Readers.

SEeing it is a fault to deliuer that in many words, which may be deliuered in few (gentle Readers) leauing the hand, by which the wits of yong beginners are hindered, dulled, and diftraɛted, learne you this fore-written Scale by numbring it : for this being knowne, you fhall moft eafily, and at firft fight know the *voyces*, *Keyes*, and all the *Mutations*.

Rules for the Keyes.

FIrst, Of the marked *Keyes* one differs from the other a Fift, except ſ *vt*, which is remoued from *F faut* a Seuenth.

2. The *Keyes* of an odde number are contained in line, the *Keyes* of an euen number in space.

3. All the signed keyes, from which the Iudgement of other *Keyes* is fetched, are set in line.

4. The Greeke Letter is placed in the baser part of the *Introductory*, in honour of the Greekes, from whom *Musicke* came to vs : For *Berno* the Abbot (in his first Booke of Musicke) saith, The Latines chose rather to put the Greeke letters than the Latine, that the Greekes may be noted hereby to be the Authors of this Art.

5. All *Keyes* beginning with one Letter, doe differ an Eight, saith *Guido cap .5.* of his *Microl.*

6. Of Eights there is the same iudgement.

7. It is not lawfull for plaine-Song to goe vnder, ſ *vt*, nor aboue *Eela*. Hereupon it is, that the Three highest *Keyes* haue no inferiour *Voyces*, because beyond them there is no rising : Neither haue the three lowermost superiour *voyces*, because there is no descending vnder them.

8. As oft as in a broken Song, you goe beyond the extreame *Keyes* (as you doe often) take your *voyces* from Eights.

THE FOVRTH CHAPTER.

Of Tones in Generall.

 Tone (as *Guido* saith) is a rule iudging the Song in the end, or it is a knowledge of the beginning, middle, and end of euery Song, shewing the rising and falling of it.

Of the number of Tones.

BY the authoritie of the Græcians, we should only obserue 4. *Tones*, (saith *Guido Microl.* 11. 1. *Proton.* 2. *Deuteron*, 3. *Triton*, 4. *Tetarton*. But the Latines considering the rising & falling, and diuiding each of the Greeke *Tones* into authenticke & plagall: to conclude euery thing that is sung within Eight *Tones*, agreeable to the eight parts of Speech. For it is not amisse, (saith *Ioan Pont. cap.* 10.) that euery thing which is sung, may be comprehended within Eight *Tones*, as euery thing which is spoken, is confined within Eight parts of Speech.

Now these Eight *Tones* (as *Franch. lib. 5. Theor.* and last Chapter, and
lib.

lib.1.pract.7. cap. saith) are by the Authors thus named, The first *Dorian;* the second, *Hypodorion ;* the third, *Phrygian;* (which *Porphyrio* cals barbarous ; the fourth, *Hypophrygian ;* the fift, *Lydian ;* the sixt, *Hypolydian ;* the seuenth, *Myxolydian ;* the eight, some call *Hypermyxolydian :* others say it hath no proper name.

Of the Finals belonging to the Tones.

FInals, (as Saint *Bernard* in his Musicke saith, both truely and briefely) are the Letters which end the Songs. For in these must be ended euery Song which is regular, and not transposed, and are in number Foure, as *Guido* writeth in the Dialogue of his *Doctrinall:*

To wit,
{ *D sol re*
E la mi
F faut
G sol re vt }
In which euery Song ends
{ *First*
Third
Fift
Seuenth }
and
{ *Second*
Fourth
Sixth
Eight }
regular *Tones*

Of the Compasses of the Tones.

THe Compasse is nothing else, but a circuite or space allowed by the authoritie of the Musitians to the *Tones* for their rising and falling.

Now to euery *Tone* there are granted but Ten Notes or Voices, wherein he may haue his course, (as Saint *Bernard* saith in the Prologue of his Musicke. Hereof hee assignes Three reasons: to wit, The authoritie of the *Decachorde* of the Psalter : the worthinesse of equalitie : and the necessity of setting the Notes downe. Although at this time the licentious ranging of our modern Musitians, doth adde an Eleuenth to each, as in the figure following appeares.

dd	1	2		3	4		5	6		7	8	
							10			10		
G				10 9 8 7 6	6		9 8 7 6			9 8 7 6 5	7 6 5	
Amb:	7 6	7 6	Ambi:	5	5	Ambi:	5 4	4	Ambi:	4 3	4 3	*Ambitus Plagales.*
Autem:	4	4	Autem:	4 3 2 1	4 3	Autem:	3 2 1	2	Autem	1	1	
	3 2 2 2	3 2 2 2		1 2	1 2 3			1 2		2 1	2 3	
f	3 4 5	3 4 5		3 4 5	4 5			3 4		1	4 5	
	Protos			*Deuteros*			*Tritos.*			*Tetartos.*		
	The First.			The Second.			The Third.			The Fourth.		

Of the Repercussions of Tones.

WHerupon the *Repercussion*, which by *Guido* is also called a *Trope*, and the proper and fit melodie of each *Tone*. Or it is the proper interuall of each *Tone*, as in the Examples following appeareth.

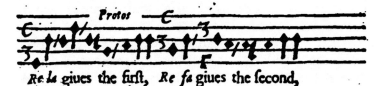

Re la giues the first, *Re fa* giues the second,

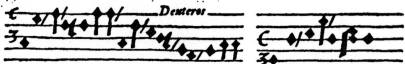

Mi mi giues the Third, *Mi la* giues the Fourth, *Vt sol* giues the Fift,

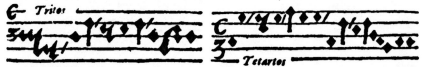

The Sixt giues *Fa la*, *Vt sol* vneuen *Tetartos*, *vt fa* doth giue the last.

Rules

Rules for the Tones.

First, All the odde *Tones* are *Authenticall*, all the euen *Plagall* : these are so called because they descend more vnder the finall *Key* : these, because they doe more ascend aboue the finall *Key*.

The second, Euery Song in the beginning, rising straight beyond the finall Note to a Fift, is *Authenticall* : but that which fals straight way to a Third, or a Fourth, vnder the finall *Key*, is *Plagall.*

The third, A Song not rising in the middle beyond the finall Note to an Eight, although it haue a Fift in the beginning, is *Plagall* : vnlesse the *Repercusion* of an *Authenticall* being there found, preserue it : as an *Antiphone* is newly found, which is iudged to be of the Eight *Tone*, because it hath not the rising of an *Authent* in the middle. But the *Repercusion* of a seuenth, appearing straight in the beginning, doth preserue it, and make it remaine *Authenticall.* See *Pontifex cap.* 12.

By how many wayes we may know the Tones.

WE may know the *Tones* by three meanes : by the beginning : the middle : and the end. By the beginning ; for a Song rising in the beginning straight wayes aboue the finall *Key* to a Fift, is *Authenticall*, as before was sayd in the second Rule. By the middle, and first, by the rising ; For the Song which toucheth an Eight in the middle, is *Authenticall* : that Song which doth not, is *Plagall* : secondly by the *Repercusion*, which is proper to euery *Tone*, as before was sayd ; by which at first hearing you may iudge of what kinde a Song is. By the end, as before we spake of the finall Notes.

Besides there be certain Songs, which do ascend as an *Authentical*, & descend as a *Plagall*, and those are called *Neutrall*, or mixt Songs, though indeede Saint *Bernard* doeth not allow of them : for he saith, what execrable licentiousnesse is this, to ioyne together those things, which are contrary one to the other, transgressing the bonds of Nature ? surely as it doth make a discontinuance in conioyning, so doth it open wrong to Nature. Therfore they are starke mad, which presume so farre as to rise a *Plagall*, and descend an *Authenticall.*

Yet are these Songs (in my iudgement) to be very diligently marked in the end, to which *Tone* they encline most. For whilest they discend from a Fift to the finall Note, they are *Authentickes* ; but whilest they rise from a Third or a Fourth to a finall, they are *Plagals* : See *Pontifex* in his 12. and 16. *chap.*

F THE

The Fift Chapter.

Of Solfaing.

Herevpon, *Solfaing* is the orderly singing of euery Song by Musicall *Voyces*, according as *Mi* and *Fa* shall require. For to *Sol fa* (as *Gaforus* witnesseth) is to expresse the Syllables, and the names of the *Voyces*.

Of three manners of Singing.

EVery Song may be sung three manner of wayes: that is, by *Solfaing*, which is for *Nouices*, that learne to sing: By sounding the soundsonly, which belongs to Instrumentists, that they may affect the mindes of them that heare or conceiue them with care or solace : Thirdly, by applying, which is the worke of the *Cantor*, that so he may expresse Gods praise.

Of Scales.

BEcause the diuersitie of *Tones* causeth a diuersitie in the *Solfaing*, especially about *mi* and *fa*, in *b fa* ♮ *mi*, which before wee concluded was not one onely *Key*, but two : therefore the industrious Musitians haue deuised Two Scales, in which euery Song doth runne, and is gouerned : and hath ordayned, that the first should be called ♮ durall of the ♮ ; the second, *b moll* of *b Flat*.

The generall description of the Scale.

THerefore generally a Scale is nothing else, but the knowledge of *mi* and *fa*, in *b fa* ♮ *mi*, and in his Eights.

What the Scale ♮ Durall is.

THe Scale ♮ *Durall* is a Progression of Musicall Voyces, rising from *A* to ♮ sharpely, that is, by the *Voyce Mi*.

What the Scale b Moll is.

BVt the Scale *b Moll* is a Progression of Musicall *Voyces*, rising from *A* to *b flatly*, that is by the Voyce *fa* : therefore a *b Moll* Scale doth alwayes require *fa* in *b fa* ♮ *mi*, and a ♮ *sharpe* Scale, *mi* : as in this draft following you may see.

Rules

The *Scale* of ♮ dure, and where the Mutations *are made.* The *Scale* of ──── b *Moll*, and where the Mutations *are made.*

Rules of Solfaing.

THe First, He that will *Solfa* any Song, must aboue all things haue an eye to the *Tone*. For the knowledge of the *Tone* is the inuention of the Scale, vnder which it runnes.

The Second, All the *Tones* runne vnder the Scale of ♮ Dure, excepting the fift and the sixt.

The Third, To haue a Song runne vnder ♮ Dure, is nothing else, but to sing *Mi* in b *fa* ♮ *mi*, and *fa* in a *flat* Scale.

The Fourth, When a Song runnes vnder a Scale ♮ Dure, the lowermost Notes of that kinde are to be sung; but vnder a Scale b *Moll*, the vppermost Notes.

The Fift, Euery *Solfaer* must needs looke, whether the Song be regular, or no; for the transposition of a Song is oft times an occasion of changing the Scale.

The Sixt, Euery Song ending in the *Finals*, is regular, and not transposed, saith Saint *Bernard* in his Dialogue.

The Seuenth, Whensoeuer a Song ascends from *F sol re* to *A la mi re* by a fift, mediately or immediately, and further onely to a second, you must sing *fa* in b *fa* ♮ *mi* in euery *Tone*, till the song do againe touch D *sol re*, whether it be marked or no. But this Rule failes, when a song doth not straightwayes fall to F *faut*, as in the Hymne, *Aue maris stella*, you may see.

The Eight, In b *fa* ♮ *mi*, and his eights, you may not sing *mi* for *fa*, nor

contrariwiſe;becauſe they are diſcording and repugnant voyces, ſaith *Fran-chinus lib.1. pract.cap.4.*

The Ninth, *b* in places, where he is marked contrary to his nature, doth note Mutation.

The Tenth, The Scale being varied, the *Mutations* are alſo with it varied, both in the whole and in part. In the whole, as in tranſpoſed Songs; in part, as in conioyned Songs.

The eleuenth, As often as *fa* or *mi* is marked contrary to their nature, the *Solfaer* muſt follow the marke ſo long as it laſts.

The twelfe, Seeing there is one and the ſelfeſame iudgement of eights, the ſame *Solfaing* of *Voyces* muſt be.

The Sixt Chapter.
Of Mutations.

Hereupon *Mutation* (as *Georg. Valla lib.3. cap.* 4. of his Muſicke proueth) is the putting of one *Voyce* for another. But this definition, becauſe it is generall, doth not properly agree to a Muſitian: therfore *Mutation* is (to apply it to our purpoſe) the putting of one concord for another in the ſame *Key.* And becauſe all *Voyces* are not concords, al do not receiue *Mutation.* Therfore it is neceſſary to conſider, to which *Voyces Mutation* doth agree, and to which not; for ♮ *dures* are not changed into *b mols*, nor cōtrarily: as you may ſee in the example following.

Rules for Mutations.

First, As often as the Progreſſion of ſixe Muſicall *Voyces* wants, there muſt neceſſarily be *Mutation*.

2 No *Mutation* can be in a *Key* which hath but one *Voyce*, becauſe there one *Voyce* is not changed into it ſelfe, although it may well be repeated.

3 In *Keyes* which haue two *Voyces*, there be two *Mutations*, the firſt is from the lower to the vpper; the ſecond contrarily. From this Rule are excepted *Keyes* which haue *Voyces* of one kinde, as *cc ſolſa*, and *dd la ſol*.

4 A *Key* hauing three *Voyces*, admitteth ſixe *Mutations*, although therein you muſt needs varie the Scale.

5 Let there be no *Mutation*, vnleſſe neceſſitie force you to it.

6 The *b moll Voyces* cannot be changed into ♮ ſquare, nor contrarily: becauſe they are diſcords.

7 Naturall *Voyces* are changed both into ♮ *Dures*, and into *b mols*, becauſe they are doubtfull: excepting *mi* and *ſol*, *re* and *fa*, which are not changed one into another; becauſe they are neuer found dwelling in one *Key.*

8 In the falling of a Song, let the lower be changed into the higher, in the riſing contrarily.

9 In a *Key* which hath one *Voyce*, there may be ſo many *Mutations*, as there may be in his eight, becauſe of them there is the ſame iudgement.

10 You muſt make a mentall, not a vocall *Mutation*, vnleſſe two or three Notes be put in the ſame place that receiues *Mutation*.

The Seventh Chapter.

Of Moodes, or Interuals.

AN *Interuall* (as *Boëtius*, whoſe conceit for Muſicke, no man euer attained *lib. 1. cap.8.* writeth) is the diſtance of a baſe and high ſound. Or (as *Placentinus lib.2.cap.8.* ſaith) it is the way from lowneſſe to height, and contrarily. Or it is the diſtance of one *Voyce* from another, conſidered by riſing and falling. Whence it is manifeſt, that an *Vniſon* is not a *Moode*, although it be the beginning of *Moodes*, as vnitie is of numbers. For *Boëtius* ſaith, As vnitie is the beginning of pluralitie, and number, ſo is æqualitie of proportions. Now an *Vniſon* is, (according to *George Valla lib.2.cap.2.*) a *Voyce* ſo qualified, that it neither tendeth to depth nor to height. Or it is a conioyning of two or three Notes in the ſame place, as appeareth in exerciſe.

Of the number of the Moodes.

NOw the vſuall *Interuals* are in number 9, *viz.* a *Semitone*, and that is a riſing from one *Voyce* to another, (by an imperfect ſecond) ſounding

 flatly

flatly: and it is onely betwixt the *Voyces Mi, fa.* It is called a *Semitone,* not becaufe it is halfe a *Tone,* (for a *Tone* cannot be diuided into two equall parts) but becaufe it is an imperfect *Tone,* for *Semum* is called that which is imperfect, as faith *Boëtius lib.*1. *cap.*16. Of how many forts a *Semitone* is, I fhall hereafter in my *Theoricks* difcuffe.

A *Tone* (as *Faber Stapulenfis* writeth) is the beginning of *Confonances* : or it is a *Confonance* caufed by the number of eight. For *Macrobius* faith, that the eight, is an number, by which *Symphonie* is bred ; which *Symphonie* the Græcians call a *Tone.* Or it is the diftance of one *Voyce* from ano- ther by a perfect fecond, founding ftrongly, fo called a *Tonando,* that is, *Thundring.* For *Tonare,* (as *Ioannes Pontifex* 12.*cap.* 8. faith) fignifieth *to thunder powerfully.* Now a *Tone* is made betwixt all *Voyces* excepting *mi* and *fa,* confifting of two fmaller *Semitones,* and one *Comma.*

A Semiditone.

WHich *Faber Stapulenfis* calleth *Sefquitonium,* is an *Interuall* of one *Voyce* from another by an imperfect third: confifting of a *Tone,* and a *femitone* according to *Placentinus.* It hath two kindes, as *Pontifex* in the eight Chapter faith ; the firft is from *re* to *fa*; the fecond from *mi* to *fol,* as in exercife will appeare.

A Ditone.

IS a perfect third : fo called, becaufe it containes in it two *Tones,* as *Placen- tine* and *Pontifex* witneffe. It hath likewife two kindes, the firft is from *vt* to *mi*; the fecond from *fa* to *la.*

Diateßaron.

IN *Boëtius lib.*1.*cap.*17. It is a *Confonance* of 4. *Voyces,* and 3. *Interuals.* Or it is the leaping from one *Voyce* to another by a Fourth, confifting of two *Tones,* and a leffer *femitone.* It hath three kinds in *Boëtius lib.*4.*cap.*13. and in *Pontifex cap.*8. the firft is from *vt* to *fa,* the fecond from *re* to *fol,* the third from *mi* to *fa.*

· Diapente.

IS a Confonance of fiue *Voyces,* and 4. *Interuals,* as faith *Boëtius lib.*1. *cap.* 18. Or it is the leaping of one *Voyce* to another by a fift, confifting of three *Tones,* and a *femitone.* It hath foure kinds in *Boëtius lib.*4. *cap.*13. Therefore *Pontifex* cals it the *Quadri-moode Interuall.* The firft, is from *vt* to *fol*; the fecond, from *re* to *la*; the third, from *mi* to *mi*; the fourth, from *fa* to *fa.*

Semitone

Semitone Diapente.

IS an *Interuall* of one *Voyce* from another by an imperfect sixt, according to *Georgius Valla lib. 3. cap. 21.* consisting of three *Tones*, and two *Semitones.*

Tonus Diapente.

IS the distance of one Voyce from another by a perfect sixt. Which *Stapulensis* affirmes to consist of foure *Tones*, and a lesser *semitone.*

Diapason.

WHich onely is called a perfect *Consonance* by *Guido* in the 9. Chapter of his *Microl.* according to the same Author in the 5. Chapter is an *Interuall:* wherein a *Diatessaron* and *Diapente* are conioyned. Or (as *Franchinus lib. 1. pract. c. 7.* writeth) is a *Consonance* of eight *sounds*, and seuen *Interuals.* Or (as *Plutarch* saith, it is a *Consonance* weighed by a duple reason. Now for example sake 6. and 12. will make a duple reason. But they to whom these descriptions, shall seeme obscure, let them take this. It is a distance of one Voyce from another by an eight, consisting of fiue *Tones*, and two lesser *semitones*. It hath seuen kindes, according to *Boëtius* and *Guido* the most famous *Musitians.* For from euery Letter to his like is a *Diapason.* Besides euery *Moode* hath so many kindes excepting one, as it hath Voyces.

Here followeth a Direction for the Moodes.

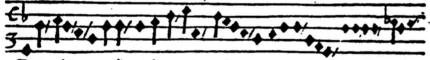

Ter tro ni sunt mo di qui bus omnis cantile na contexitur, scilicet, Vnisonus, Se mi-

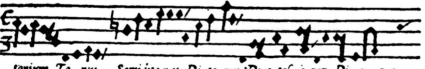

tonium, To nus. Semitonius, Di to nus, Di a tes, e ron, Di a pen-

te, Semitonius diapente, To nus cum diapente, huc modis di a pason, Si que de-
lectat

lectat eius hūc modū cū cognoſcat cūq̃, tā paucis mo dulis to ta harmonia formetur,

vtiliſsimum eſt eam alta memoriæ cōmendare, nec ab homini ſtudio re quieſce re, Do-

nec vocū interuallium cog ni tū Harmōta totius facilime queat cōprehēdere noticiam.

Of the forbidden Interuals.

THere be ſome other *Interuals,* very rare, and forbidden to yong begin-
ners. For as the learned licence of Orators & Poets, doth grant certaine
things to thoſe which are as it were paſſed the age of warfare, but doth de-
ny the ſame to freſh-water ſouldiers; ſo is it amongſt Muſitians. The names
of thoſe are theſe.

Tritonus.

ANd it is a leaping from one Voyce to another by a ſharp Fourth, com-
prehending three whole *Tones* without the *ſemitone.* Wherefore it is
greater than *Diateſſaron; Stapulenſis* ſaith thus, A *Tritone* doth exceed the
Conſonance of a *Diateſſaron.* And this *Moode* is vſed in the anſwere, *Iſti ſunt
dies, Dominica Iudica:* and in the anſwere, *Vox Tonitrui,* in the ſaying, *Euan-
geliſta,* as thus:

Io an nes eſt Euange li ſta.

Semidiapente.

IS an *Interuall* by an imperfect fift, comprehending two *Tones,* with two
ſemitones, which though it be not found in plaine-ſong, yet doth the
knowledge thereof much profit compoſers, who are held to auoide it.

 Semiditones

Semiditonus Diapente.

I S an *Interuall* by an imperfect seuenth. This according to *Placentinus lib.3.cap.* 24. comprehends foure *Tones*, and two *semitones*. The example of this is in an *Antiphone* called, *Dum inducerent puerum Ihesum*, in the speech, *Accepit*

Parentes e ius ac ce pit.

Ditonus Diapente.

I S the distance of one Voyce from another by a perfect seuenth : consisting of fiue *Tones*, and one *semitone*, according to *Georg. Valla lib.3. cap.* 26. It is found in the *Responsorie*, *sancta legio de sancto Mauritio*, in the word, *Aganensium*.

sancta le gio Aganensium

Semidispason.

I S an imperfect eight, consisting of foure *Tones*, and three *Semitones*, not to be vsed in any plaine Song, yet worthy to be knowne by componists.

Semitonium Diapason.

I S a leaping by an imperfect Ninth, consisting of fiue *Tones*, and three *semitones*. Now a *Tone* with a *Diapason* is a perfect Ninth, consisting of sixe *Tones*, and two *semitones*.

Semiditonus Diapason.

I S an *Interuall* by an imperfect Tenth, as witnesseth *Valla* the 31.Chapter, consisting of sixe *Tones*, and three *sem.tones*. A *Ditone* with a true *Diapason* is a perfect Tenth, consisting of seuen *Tones*, and two *semitones*.

Diapason Diapente.

I S a consonance of twelue *sounds*, and eleuen *Interuals*, consisting of eight *Tones*, and three *semitones*. The examples of these *Moodes* are verie rarely scene in plaine Song; in mensurall often.

Disdiapason.

I S an *Interuall* by a Fifteenth, occasioned (as saith *Macrobius*) by a quadruple proportion. Wherein antiquitie sayd we should rest, and goe no

H further,

further,as *Ambrosius Nolanus* doth proue in the prouerb *Piscixpasen*, which is in *Erasmus* that other light of *Germany*. Both becausethis is the naturall compasse of mans voice, which going aboue this,is rather a squeaking;and going vnder,is rather a humming than a *Voyce :* And also because *Aristotle* doth deny Musick to be meerely Mathematicall. For Musick must be so tempered, that neither sence be against reason, nor reason against sence.

<div align="center">

The Eight Chapter.

Of the Dimension of the Monochord.

</div>

Monochord, that is,an Instrument of one string, is thus truely made.Take a peece of wood of a yard long, or what length you please, of two fingers bredth,and so thicke, make it hollow in the middle, leauing the ends of it vnhollowed. Let it be couered with a belly peece well smoothed, that hath holes in it,like the belly of a Lute:through the middle of this,let there be secretly drawne one line, and in the beginning of it, let one pricke be marked with the letter *F.*for that shalbe the first *Magade* of the Instrument : then diuide the whole line from the pricke *F.* into nine equall parts, and in the first pricke of the diuisions place *vt*, in the second nothing, in the third *Cfaut,* in the fourth nothing,in the sift *Gsolreut*,in the sixt *Csolfaut*,in the seuenth *Gsolreut* small, in the eight nothing, in the last o *Cifer,* which shall possesse the place of the second *Magade.* This done, againe diuide the space,which is from *vt* to the second *Magade*,into nine parts.

In the first part set *A* Base; in the third *Dsolre*; in the sift *Alamire*; in the sixt *Dlasolre:* in the seuenth *aalamire.* Then from *Are* to the second *Magade* againe make nine parts;in the first set ♮ *mi* Base; in the third *Elami*;in the sift ♮ *mi* in the small letters ; in the sixt *Elami* ; in the seuenth ♮ ♮ *mi* double.

This done, diuide all this space from the first to the second *Magade* into foure parts: in the first put *Efa* Base ; in the second *Ffaut* small ; in the third *Ffaut* sharpe. Then begin in *Bfa* Base, and diuide the whole line towards the *Cone* into 4 parts ; in the first,*b* the *Semitone* betwixt *D* & *E* capitals ; in the second,*b fa*; in the third, *bb fa* This done,begin in the *semitone*,which is betwixt *L* & *E*, and diuide the whole line into 4. equall parts. In the first, place *b* the *Semitone*, betwixt *G* capitall and small ; in the second,*b Semitone*,betwixt *D* and *E* ; in the third,*b fa*, betwixt *dd* and *ee*: and if you further diuide the third into two equall parts,you shall haue a *semitone* betwixt *y* and *ea.* Then place the foot of your compasse in *Csolfaut*, and diuide the space towards the second *Magade* into two parts ; in the middle whereof place *a soifa*. In like manner diuide the space from *dlasolre* towards the *Cone* into two equall parts ; and in the middle place *ddlasol.* Lastly,diuide the space from *e* towards the second *Magade* ; and in the middle you shall haue *ee b,* with the true *Dimension* of the *Monochord.* This done,in the extreame

<div align="right">points</div>

points of the *Magades*, set little props to hold the string, least the sound of the string be dulled with touching the wood. This readied, set to one string of wyre, strong, big & stretched inough, that it may giue a sound which may be easily heard, and you shall haue your *Monochord* perfect. The forme of it is this.

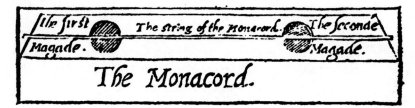

| the first Magade. | The string of the Monacord. | The seconde Magade. |

The Monacord.

The Ninth Chapter.

Of the Definition, Profit and vse of the Monochord.

A *Monochord* (as *Guido* proues in the beginning of his *Doctrinals*) is a long square peece of wood hollow within, with a string drawne ouer it; by the sound whereof, we apprehend the varieties of sounds. Or it is a rude and vnskilfull Maister, which makes learned Schollers. For it shewes to others that which it selfe conceiues not, it tels truth, it cannot tell how to lye, it instructeth diligently, and reprehendeth no mans slow conceit. Now it is called a *Monochord*, because it hath but one string, as a *Tetrachord* is called that which hath foure. And a *Decachord* which hath tenne, saith *Io.m. Pont. 22. cap.7:* of his Musicke.

Of the profit of the Monochord.

THe *Monochord* was chiefly inuented for this purpose, to be iudge of Musical voices and interuals: as also to try whether the song be true or false: furthermore, to shew haire-braind false Musicians their errors, and the way of attaining the truth. Lastly, that children which desire to learne Musicke, may haue an easie meanes to it, that it may intice beginners, direct those that be forward, and so make of vnlearned learned.

Of the vse of the Monochord.

THe vse of the *Monochord* (saith *Berno Cluniacenss lib. 2.* of his Musicke) is, that we may know how much each voyce is higher or lower than other. When therefore thou wilt learne a Song, euen the deepest, or thy selfe by the helpe of thy *Monochord*, set thy *Monochord* before thee on the table, and marke in what Key the first Note of that Song is, which thou desirest to know. This being found, touch the same in the *Monochord* with a quill, and the sound it giues, is that thou desirest. Thus runne ouer each Note of the

Song, and so mayest thou by thy selfe learne any Song though neuer so weighty.

The Tenth Chapter.

Of Musica Ficta.

 Ained Musicke is that, which the Greekes call *Synemenon*, a Song made beyond the regular compasse of the Scales. Or it is a Song, which is full of Coniunctions.

Of Coniunctions.

THe Coniunct sounds were called by the ancients *Dijuncts* because it is added to songs besides their nature, either to make them more sweet, or to make the *Moodes* more perfect: for thus saith Saint *Bernard*: In euery kinde, where it is meet a flatter sound should be, let there be put a flat in stead of a sharpe; yet couertly, least the Song seeme to take vpon it the likenesse of another *Tone*. Now a *Coniunct* is this, to sing a Voyce in a *Key* which is not in it. Or it is the sodaine changing of a *Tone* into a *Semitone*, or a *semitone* into a *Tone*.

Of the Diuision and number of Coniuncts.

COniuncts are two-fold: that is, Tolerable ones, when a Voyce is sung in a *Key*, wherein it is not, yet is found in his eight: as to sing *Mi* in *A re*, *La* in *Dsolre*. Intolerable ones, when a Voyce is sung in a *Key* which is not in it, nor in his eight, as to sing *Fa* in *Elami*, *Mi* in *Ffaut*. Of these *Coniuncts* there be two signes, *viz.* b round and ♮. The first sheweth that the *Coniunct* is in ♮ *dure* places; the second, that it is in *b flat* places.

There be 8. *Coniuncts* most vsuall: although there may be more. The first in a Base, is marked with round b. The second in E finall, is marked with the same signe. The third is in *Ffaut*, and is marked with ♮. The fourth in a small, is knowne by *b fl.t*. The fift, in *c* affinall by ♮ *dure*. The sixt, in *e* by *b* round. The seuenth, in *f* by ♮. The eight in *aa* by *b*. There be examples enough to to be found of these both in plaine and mensurall Songs.

Here followes the fayned Scale.

THe fained Scale exceedes the others both in height and depth. For it addeth a *Ditone* vnder *Vt* base, because it sings *fa* in *A*, and it riseth a-boue *eela* by two degrees, for in it it sounds *fa*. Wherfore for the expressing of it, there are necessarily required twelue lines, as appeareth in the figure following.

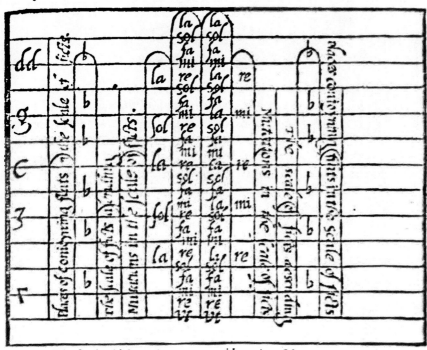

The Scale of ficts or Synemenon, and how the Mutations are made.

Rules for Ficta Musicke.

FIrst, It is better, and sweeter to sing by tolerable *Coniuncts*, than by the proper Voyces of *Keyes*.

2 The tolerable *Coniuncts* doe not spoyle the Song, but the intolerable ones.

3 Musicke may Fict in any Voyce and *Key*, for Consonance sake.

4 Marking *fa* in *b fa b mi*, or in any other place, if the Song from that shall make an immediate rising to a Fourth, a Fift, or an Eight, euen there *fa* must necessarily be marked, to eschew a *Tritone*, a *Semiдиapente*, or a *Semidiapason*, and inutuall, and forbidden *Moodes*: as appeareth in the example vnder-written.

An Exercise of Ficta Musuke.

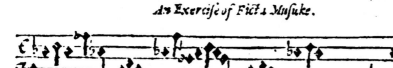

The Eleventh Chapter.

Of Song and Transposition.

Herefore a Song is a melody formed of a *Sound*, *Mood*, & *Tone*, by a liuely Voice. I say by a *sound*, becaufe of the writing of the Notes, which improperly we call a Song: By the *moode*, I vnderftand rifing and falling, becaufe of the prayers which are read in an Vnifon. By the *Tone*, becaufe of the chirping of birds, which is comprehended within no *Tone*. For within a *Syllogifme* is *moode* and *figure*, that in a Song is the *Tone* and Scale. I fay a liuely Voyce, becaufe of Muficall Inftruments. Or otherwife: A Song is the fitting of a liuely Voyce according to rifing, and falling, Or (as *Gafforus* writeth in his *Theoricks lib. 5. cap. 6.*) it is the deduction of many Voyces from the fame beginning. And this defcription doth properly agree to this progreffion of fyllables, becaufe it is not a Song.

Of the number of Deductions.

THere are therefore three Deductions of this kinde: the firft is called ♮ *durall*, to be fung fharpely, becaufe it requires *mi* in *b fa* ♮ *mi*, and in his Eights.

The fecond is *b flat*, which runneth with a fweet and flattering Harmonie, and requires *fa* in *b fa* ♮ *mi*.

The third is *neutrall*, and is called *naturall*. For it receiueth in *b fa* ♮ *mi*, neither *mi*, nor *fa*: becaufe it comes not to fuch places.

Rules for Deductions.

FIrft, Wherefoeuer *Vt* is put in the Scale, there is the beginning of fome *Deduction*: where *fa* is put, there the middle: where *la*, there the end: as appeareth in the figure following.

In $\begin{Bmatrix} C \\ F \\ d \end{Bmatrix}$ *Naturall*, $\begin{Bmatrix} F \\ b \\ d \end{Bmatrix}$ *b Moll* $\begin{Bmatrix} b \\ c \\ e \end{Bmatrix}$ and ♮ *dure* $\begin{Bmatrix} \text{the beginning,} \\ \text{middle,} \\ \text{end.} \end{Bmatrix}$

The fecond Rule. Of which *Deductions* this or that rule is, you fhall thus eafily know. Confider the voice that is there to be fung, with which it defcends to his foundation, I fay to *Vt*: and where you find any fuch, fee what *Deduction* begins fo: for it will be of that Note which you feeke.

Of Transposition.

WHereupon *Transposition* is the remouing of a Song, or a *Key* from his proper place. For to transpofe is to remoue a fong, or a *Key* from the proper place. And *Transposition* is two-fold, *viz.* Of the Song and of the *Key*.

Of Transposition of a Song.

IT is the avoiding of *Coniuncts*, for whilst we striue to avoide *Coniuncts*, (because they marre the Song) we doe eleuate the Song from the proper place of his end, aboue to a Fift, as directly appeareth in the Responsorie, *Ite in Orbem.*

I te in Orbem　　　I te in or bem

Of the Affinall Keyes of Tones.

THe *Keyes* (which we call *Affinall*) be the Letters, which end irregular Songs : whereof according to *Guido, Berno,* and Saint *Gregory,* there be three : Although the *Ambrosians* make more.

Viz. $\begin{Bmatrix} alamire \\ b\, fa\, \natural\, mi \\ c\, solfaut \end{Bmatrix}$ wherein ends euery Song of the $\begin{Bmatrix} First \\ Third \\ Fift \end{Bmatrix}$ and $\begin{Bmatrix} Second \\ Fourth \\ Sixt \end{Bmatrix}$ transposed *Tone.*

Now this irregularnesse of Songs (as writeth *Pontifex* 14. chapter of his Musicke) comes sometime by licence, sometime by the negligence of the *Cantors,* sometimes by reason of ancientnesse, which cannot be gainesaid, sometimes because of the *Counterpoint,* that the Base may haue place to descend.

Of the Transposition of a Rule.

First, A Song of the seuenth and eight *Tones* is not transposed. Not vpward to *Dlasolre,* as the *Ambrosians* are of opinion, because an *Authentick Tone* hath no place of rising to the tenth, neither down to *Cfaut,* because a *Plagall* hath no place of falling to a fift: neither must you clime aboue *eela,* nor descend vnder *r vt,* as before hath been declared. Wherfore (saith *Ioan. Pontif.*) It is fit, that he which cannot haue a Vicar, doe administer his businesse himselfe.

2 A Song ending in *Dlasolre,* or in *Cfaut,* is either an *Ambrosian* Song, or corrupted with the ignorance of *Cantors,* as *Pontifex* saith; Whensoeuer in a Song of the fourth *Tone,* there fals any missing, let vs say, that it proceeds from the vnskilfulnesse of the *Cantors,* and is to be corrected with the cunning of the Musitians. But the authoritie of the *Gregorians* admits no such Song.

3 The placing of one strange Voice in any *Key,* is a cause, why the whole Song is transposed.

4 *Transposition* is an helpe and excuse of the *Coniuncts.*

5 Let euery transposition be from a *Finall,* to a fift the proper *Affinall:*

vnleſſe neceſſitie compell, that it be to be made to a fourth. For then are we forced to tranſpoſe it to a fourth, when after the Tranſpoſition to a fift more *Coniuncts* riſe than were before: as in the anſwere, *Quæ eſt iſta,* vnder the third *Tone* may appeare.

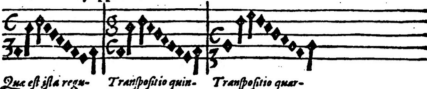

Quæ eſt iſta regu- *Tranſpoſitio quin-* *Tranſpoſitio quar-*
lariter. *taria non valens.* *taria bene valens.*

6 The ſame Voices after Tranſpoſition are to be ſung, which were ſung before.

7 In irregular Songs tranſpoſed to a fift, you muſt ſing *Mi* in *b faꞕ mi* in euery *Tone,* vnleſſe it be ſpecially marked with *fa.*

8 In Songs tranſpoſed to a fourth, *fa* is alwaies ſounded in *b faꞕ mi* : vnleſſe *Mi* be ſpecially noted.

9 Tranſpoſition to a fourth is knowne, when a Song is ended by a voice which agrees not to his Scale. Or when in the beginning of a tranſpoſed Song, *fa* is found. To which tranſpoſition Saint *Bernard* ſeemes to be oppo-

Note. ſite, in ſaying this: It is fit that they which propound to themſelues an orderly courſe of life, haue alſo the Art of Singing; and reſtraine from the liberty of thoſe men, which regarding rather likeneſſe than nature in Songs, diſioyne thoſe things which are ioyned together, and ioyne together thoſe things which are diſioyned, begin and end, make low and high, order and compoſe a Song, not as they ſhould, but as they liſt: for by the fooliſh tranſpoſition that ſuch men vſe, there is growne ſuch confuſion in Songs, that moſt are thought to be of a contrary faſhion.

10 A Song ending in *Gſolreut,* marking *fa* in *b faꞕ mi* is of the firſt or ſecond *Tone* tranſpoſed to the fourth. And that which is in *alamire,* is of the third or fourth, as *Quæ eſt iſta,* and ſo of others.

Of the Transposition of Keyes.

T He *Tranſpoſition* of a *Key* is the raiſing or low carying of a marked *Key* for want of lines, of which there are theſe Rules giuen.

1 The tranſpoſition of *Keyes* doth not make the Song irregular, becauſe it varies not the regular end.

2 By how much a tranſpoſed *Key* doth deſcend from the former going before; ſo much doth the following Note aſcend aboue that tranſpoſed *Key* : and contrarily, as in the examples following is manifeſt.

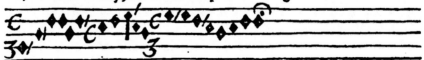

Hæc ſunt cóminia quã tibi placẽt ô patris ſapientia

THE TVVELFTH CHAPTER.

Of the Tones in speciall.

BEing that to proceed from generaltie to specialty is more naturall to vs, as *Aristotle* the Prince of all Philosophers, and light of naturall knowledge, in the first Booke of his Phisickes sheweth. Therefore in a fit order after the generall deliuery of the *Tones,* let vs goe to the speciall, discussing more largely and plainely of the nature of each. And first, of the first.

Of the first Tone.

THe first *Tone* (as S. *Bernard* saith) is a Rule determining the *authentick* of the first kinde. Or it is the *authenticall* progression of the first. Now an *authenticall* progression, is the ascending beyond the *Finall Key* to an eight, & a tenth. And the progression of the first is formed by that kind of *Diapente,* which is from *d* to *a* : and of that kind of *Diatessaron,* which is from *a* to *d;* saith *Franchinus lib.1.pract.cap.*8. It hath his *Finall* regular place in *Dsolre,* or his vnregular in *alamire.* The beginnings of it according to *Guido* are *C. D.E.F.G.* and *a,* whose capitall forme is this:

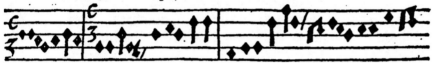

Capita. primi toni. Sacerdos in æternum. Gaudeamus omnes in do.

Of the differences of Tones.

DIfferences of the Essences of *Tones* there be none, but for the vnlearned there are some framed, that they may the easilier begin in the diuers beginnings of *Tones* : saith *Pontif.*23. chapter of his Musicke. Therefore I find no cause of this, but onely vse : neither haue I found it written by any Musitian. Neither doth Saint *Bernard* much like it. For the differences giue occasion of many confusions and errours. Wherefore seeing our obsequiousnesse, which we performe to God, must be reasonable, leauing the differences, which are by no reason approued, let the Readers onely be carefull of the Capitall tenours of *Tones,* least they wind themselues in vnprofitable and superfluous precepts, put on the darkenesse of the night, and make an easie thing most hard and difficult. For God delights not in vnreasonable turnings, but in Songs well fashioned and regular, being he himselfe hath made all things in a most regular and orderly fashion. Wherefore the Psalmist saith, *Praise the Lord in well-sounding Cymbals:* for he would not haue said well sounding, if he would haue had God praised with euery bellowing, screaming, or noyse.

Of the Diuisions of the Psalmes.

I Find there are two sorts of Psalmes, which we vse in praising God, the greater and the lesser : all Psalmes are called lesser, except those two, *viz.* Of the blessed Virgin, and of *Zacharias.* Also the Song of *Symeon,* in some Diocesse is accounted for a greater Psalme, in some for a lesser; as I in going ouer the world haue found.

Of the true manner of Singing Psalmes.

THe authoritie both of *Cælius Rhodiginus,* and of al the Diuines doth testifie, That the Prophet had a great mysterie in the Harmony of the Psalmes : wherefore I thought good to interlace some within this booke of the true manner of singing. Whence to sing psalmes, is to sing the praises of almighty God with a certaine ioy. In which matter there is such diuersitie, (the more is the griefe) that euery one seems to haue a seuerall fashion of Singing. Neither doe they obserue the Statutes, and precepts of their forefathers, but euery one sings Psalmes, and other things euen as they list. Wherevpon there is such discention growne in the Church, such discord, such confusion, that scarce two sing after one manner. This doth *Pontifex* in the 22. chapter of his Musicke, very much reprehend, and surely with good reason, saying : Seeing that one God is delighted with one baptisme, one faith, and the vnity of manners, who may think but that he is grieuously offended with this multiplicity of Songs? Wherfore I had deliuered certaine Rules of the true order of singing, vnlesse I had found them both copiously and learnedly written by maister *Michael Galliculo de Muris,* a most learned man. Wherefore I send all that are desirous to be instructed in this point to him, onely medling with those things which belong to the tuning of psalmes.

Rules for the tuning of Psalmes.

FIrst, All the greater Psalmes are to be tuned with a rising, the lesser without a rising.

 2 The indeclinable words, the Hebrew, and Barbarous, are to be pronounced in the middle accent high.

 3 The tuning of the lesser Psalmes of the first *Tone* is thus out of *alamire,* and out of *Ffaut,* the tuning of the greater thus:

Laudate pueri do laudate nomen domini : memento do. D.. Magnificat anima mea dominum.

The melodie of verses in Responsories, is framed by later Musitians at their pleasure : but of entrances the manner is as yet inuiolably kept, according to the decrees of the Ancients, in this manner.

The

The Melodie of the Verses in the answeres of the first Tone.

The Melody in the beginnings of the Verses of the first Tone.

Of the second Tone.

THe second *Tone,* (as Saint *Bernard* saith) is a Rule determining the *Plagall* of the first fashion. Or it is a plagall Progression of the first. Now a *plagall* Progression is a descending beyond the *Finall* to a Fift, or at least a fourth. His beginnings (according to *Guido*) are *A.C.D.F.& G.* & doth rightly possesse the extreames of the eight *Authenticke,* because the souldier by law of Armes, doth dwell in the Tents of his captaine. The manner of the second *Tone,* is thus:

Cap. secūdi tõni. Miserator do mi nus. Hunc mundū spernes.

The tuning of the smaller Psalmes is thus out of *Ffaut;* the tuning of the greater out of *Cfaut,* thus:

Laudate pueri do. laudate nomē do· Memento do.da. Magnificat anima mea dominum.

The Melodie of the Verses in the answeres of the second Tone.

The Melodie in the beginnings of the Verses of the second Tone.

Of the third Tone.

THe third *tone,* is a Rule determining the *Authenticall* of the second maner. Or it is the *authentical* progressiõ of the secõd, hauing the final place

regular in *Elami*: His beginnings (according to *Guido*) are E.F.G. &c. The chiefe forme whereof, is this:

Capitale tertij. O gloriosum. Fatus distillans.

The tuning of the lesser Psalmes out of Csolfaut, *and of the greater out of* Csolreut, *is this* :

Laudate pueri do laudate nomen do: Memento do Da. Magnificet anima mea.

The Melodie of the Verses in the answeres of the third Tone.

The Melodie in the beginnings of the Verses of the third Tone.

Of the Fourth Tone.

THe Fourth *Tone* (as witnesseth *Bernard*) is a Rule determining the *plagall* of the second manner. Or it is a Progression of the second *plagall*, holding the same end that his *Authenticke* doth. It hath sixe beginnings, C. D.E.F.G. and *a*, whose principall tenour is this, as it followeth:

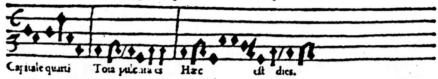

Capitale quarti Tota pulchra es Hæc est dies.

The tuning of the smaller Psalmes out of *alamire*, and the greater out of *Elami*, is thus :

Laudate pueri dominû, laudate nomê domini. Memento do. Da Magnificat anima mea dominû.

The Melodie of the Verses in the answeres of the fourth Tone.

The

The Melodie in the Diuine Offices of the Verses of the Fourth Tone.

Of the fift Tone.

THe fift *Tone* is a Rule, determining the *Authenticke* of the third manner, or it is an *Authenticall* Progression of the third. Whose regular end is in *Ffaut*; and irregular end in *Csolfaut.* The beginnings of it (as *Franchinus* witnesseth) are Foure, *F.G.a,* and *c.* whose chiefe forme is this :

Cantice quinti. Gaude Dei genitrix. Gau di a.

The tuning of the smaller Psalmes out of *Csolfaut,* and of the greater out of *Ffaut,* is in this sort.

Laudate pueri dominum. Memento do. Da Mag anima mea dominum.

The Melody of the Verses in the answeres of the Fift Tone.

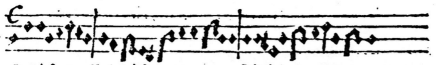

The manner in the beginnings of the Verses of the Fift Tone.

Of the Sixt Tone.

THe Sixt *Tone* is a Rule, determining a *plagall* of the third sort. Or it is the *plagall* Progression of the third, participating iustly with his *Authen-ticall* in the finall Notes. To whom there befall foure beginnings, *viz.C.D.F.* and *a,* saith *Franchinus* in the 13. chapter of his *Practick;* and *Guido* in his doctrinall Dialogue. The chiefe forme of it is this :

Cantic. Sexti. Veni electa mea. Diligebat eam.

The tuning of the lesser Psalmes out of *alamire,* and greater out of *Ffaut,* is this :

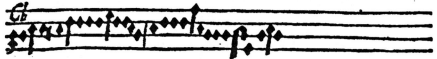

Laudate pueri dom. laudate nomen do. Me. dom. Da. Magnificat anima mea dom.

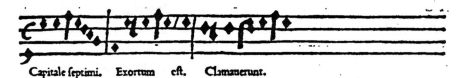

The Melodie of the Verses in the answeres of the Sixt Tone.

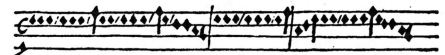

The Melody in the beginnings of the Verses of the Sixt Tone.

Of the Seuenth Tone.

THe Seuenth *Tone* is a Rule determining the *Authenticke* of the fourth sort. Or it is the *authenticall* Progression of the Fourth. It hath his end in *Gsolreut* regular only. To this belongs fiue beginnings, *viz. G.a.b.c. & d.* The chiefe forme of it, is this:

Capitale septimi. Exortum est. Clamauerunt.

The tuning of the lesser Psalmes out of *Dlasolre*, and of the greater out of *bfa♮mi*, is thus:

Laudate pueri dom. laudate nomen dom. Memento do. Da. Magnificat anima mea dom.

The Melodie of the Verses in the answeres of the Seuenth Tone.

The Melodie in the beginnings of the Verses of the Seuenth Tone.

Of the Eight Tone.

THe Eight *Tone* is a Rule determining the *plagall* of the fourth sort. Or
it is the *plagall* Progression of the fourth, possessing the same end that
his *Authenticke* doth. The beginnings of it are *D. F. G. a.* and *c.* The chiefe
forme of it, is this following:

Capitale octaui. Dum ortus. Iust. confitebuntur.

The tuning of the lesser Psalmes out of *Csolfaut*, and of the greater out
of *Gsolreut*, is thus :

Laudate pueri dominū, laudate nomé do. Memento do. Da. Magnificat anima mea dom.

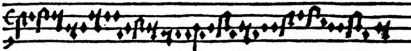

The Melodie of the verses in the answeres of the Eight Tone.

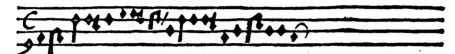

The Melodie in the beginnings of the verses of the Eight Tone.

Of the strange Tone.

THere is another *Tone*, which many call the *Peregrine*, or strange *Tone*,
not that it is of strange Notes, but that it is very seldome vsed in our
Harmony. For his Tenor is not sung to any but to one *Antiphone, Nos qui
viuimus &c.* and to two Psalmes, *In exitu &c.* and *Benedicite.* His end is in
the small Note of the Seuenth *Tone,* as *Franchinus* demonstrates it. The
Tenour of it followeth:

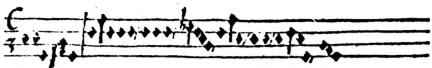

Peregrinus tonus. In exitu Israel de Egy.domus Iacob de pop. barbaro.

That diuers men are delighted with diuers Moodes.

Very mans palate is not delighted with the same meate (as *Pon.* writes in the 16.ch. of his Musick.)but some delight in sharp, some in sweet meates: neither are all mens eares delighted with the same sounds: for some are delighted with the crabbed & countly wandring of the first *Tone*. Others do affect the hoarse grauitie of the second: others take pleasure in the seuere, & as it were disdainful stalking of the third: others are drawn with the flatring sound of the fourth: others are moued with the modest wantonnes of the fift: others are led with the lamenting voyce of the sixt: others do willingly heare the warlike leapings of the seuenth: others do loue the decent, & as it were, matronall carriage of the eight. Neither is it marnell, (saith *Guido* in the 13. cha. of his *Mic.*)if the hearing be delighted with the variety of sounds, seeing that the sight, is pleased with the variety of colours, the smelling power, with the variety of odours, & the taste, with diuersity of meats. Wherfore let a Musitian diligently obserue that he dispose his song in that *Tone*, wherein he knows his auditors are most delighted. As if he will compose a song at the request of yong men, let it be youthfull and frolicke; If at the request of old men, let it be testy, and full of seuerenes. For as a writer of Comedies, if he giue the part of a yong man vnto an old man, or the part of of a wanton fellow to a couetous person, is laughed to scorne: so is a singer if he bring in a dauncing merry moode, when occasion requires sadnes, or a sad one, when it requires mirth. Now by what means that may be performed, the property of the *Moodes* declareth. Because(as *Cassiodorus* writes in an Epistle to *Boëtius*, & *Cælius* repeats it in *antiq. lect. lib. 5. cap. 22.*) The Darian *Moode* is the bestower of wisedome, and causer of chastity. The *Phrygian* causeth wars, and enflameth fury. The *Eolian* doth appease the tempests of the minde, and when it hath appeased them, luls them asleepe. The *Lydian* doth sharpen the wit of the dull, & doth make them that are burdened with earthly desires, to desire heauenly things, an excellent worker of good things. Yet doth *Plato lib. 3. de Rep.* much reprehend the *Lydian*, both because it is mournful, and also because it is womanish. But he alloweth of the *Dorian*, both because it is manly, & also doth delight valiant men, & is a discouerer of warlike matters. But our men of a more refined time do vse somtime the *Dorian*; somtime the *Phrygian*; sometime the *Lydian*; sometime other *Moodes*: because they iudge, that according to diuers occasions they are to choose diuers *Moodes*. And that not without cause: for euery habit of the mind is gouerned by songs, (as *Macrob.* writeth)for songs make men sleepy, and wakefull, carefull, & merrie, angry, & merciful. Songs do heale diseases, & produce diuers wonderful effects(as saith *Fran. Petrac.*) mouing some to vain mirth, some to a deuout & holy ioy, yea ofttimes to godly teares. Of al which I had rather be silent, than to determine any thing rashly: least I do burthen the wits of children with vnprofitable & vnnecessary precepts. Because whoso in expounding any thing doth poure on more than is needful, increaseth the darknesse, and maketh not the mist thinner, as *Macrobius* saith in the second booke vpon the dreame of *Scipio*. Therfore let learners study those few precepts, because they are necessary for the vnderstanding of that which followes.

Here endeth the first booke.

TO THE WORTHY HIS

kinde friend *George Brachius*, a moſt ſkilfull Mu-
ſitian, and chiefe Doctor of the Duke of *Wittenberg* his Chappell:
Andreas Ornithoparchus of *Meyning*, with all health.

Hen I had throughly ruminated of that ſaying of Plato,
That we were not made for our ſelues, but to doe good to
our Countrey, and friends, I was euen out of heart, my
moſt reſpected friend) euen as if my powers had fayled
me, and as one ſtroken with amazement. And as that firſt
Monarch of the Romane Empire, when he firſt ſaw Alex-
anders ſtatue at Gades, lamented for that he himſelfe had
done nothing worthy the remembrance: euen ſo I becauſe
I haue done no ſuch thing, did euen lament; conſidering that beauty, pleaſures,
age, health, and delicacies dee fade away, Sed famam extendere factis, hoc vir-
tutis opus. Wherefore after many harty ſighes, taking heart againe (though I were
toſſed with many flouds of Cares, many guſts of aduerſities, and many ſtormes of
diuers perturbations) yet began I to thinke what I ſhould leaue to poſteritie for
witneſſe that I had liued. Now my mind being turned hether and thither, in
the end I choſe the learning of Harmony, both becauſe it is fit for morall educati-
on, and alſo becauſe it is the ſeruant of Gods praiſe. For amongſt all Scholler-like
Arts, (which they commonly call Liberall) none is more morall, more pleaſant,
more diuine, than Muſicke. Whereof although there be many Profeſſors, yet be
there very few writers (I know not whether it grow out of hatred to the Art,
or their owne ſlothfulneſſe) that haue deliuered the Art in a good forme. Hence is
it, that excepting thoſe which are, or haue been in the Chappels of Princes, there
are none, or very very few true Muſitians. Whereupon the Art it ſelf doth grow in-
to contempt, being hidden like a Candle vnder a buſhel, the praiſing of the almigh-
ty Creator of all things decreaſeth, and the number of thoſe which ſeeke the ouer-
throw of this Art, doth dayly increaſe throughout all Germany. By this occaſion
ſtirred vp, & further relying vpon your kindnes, moſt worthy Sir, (a great teſti-
mony whereof you gaue me, when I came to the Vniuerſity of Tubyng, & turned
in at your pleaſ [ant] (indeed moſt pleaſant houſe) which you haue of your Prince gift)
I turned my pen to the writing of Menſural Muſick, hauing before writ of Plain-
Song. And what flowers ſoeuer other mens volumes had in them, like a Bee I
ſucked them out, and made this ſecond Book the hiue to lay them vp in. Now as I
haue dedicated it in your name, ſo doe I ſubiect it to your cenſure, that you may
both mend thoſe faults you find in it, and defend it from the barking of thoſe
who doe commonly defame all good men. For hauing a fit iudge of thoſe things
which I write, I do fitly ſubmit my ſelfe to his Cenſure, euen him whom alrea-
die both my owne experience hath found, and all Suedia doth acknowledge, and
all high Germanie doth honour for a godly, vpright, and learned man. Farewell,
(my deare friend) and defend thy Andreas from the teeth of Enuie.

M THE

THE SECOND BOOKE

of *Ornithoparchus* his Mulicke: wherein are
contained the Rudiments of Menlurall Song.

THE FIRST CHAPTER.

Of the Profit and Praife of this Art.

 Oḗtius that Romane, (whole wit in Mulicke no man euer
mended; nay, neuer attained to, in the firſt Chapter of his
Mulicke) writes, That there is ſuch efficacie in Harmoni-
call Conſents, as a man though he would, cannot want
them. For Mulicke driueth away thoſe cares which driue
away ſleepe, ſtilleth crying children, mitigateth the paine
of thoſe which labour, refreſheth wearied bodies, refor-
meth appaſſionate minds. And euery liuing ſoule is ſo ouercome with Mu-
ſicall ſounds; that not onely they which are of the gallanter ſort (as ſaith *Ma-
crobius*) but euen all barbarous Nations doe vſe Songs, either ſuch as ſtirre
them vp to an ardent embracing of vertue; or doe melt them in vnwor-
thy pleaſures: and ſo are they poſſeſſed with the ſweetneſſe of Harmony,
that by Mulicke the *Alarum* to warre is giuen, by Mulicke the Retraite is
ſounded, as if the Note did both ſtirre vp, and after allay that vertue of for-
titude. Now of the two, that Mulicke which we call Menlurall, doth ſpecially
performe theſe effects. For this (as *Iſidorus* ſaith) ſtirreth vp not onely men,
but alſo beaſts, ſerpents, birds, and Dolphins with the ſweetneſſe of the har-
mony. By this did *Arion* preſerue himſelfe in the middle of the ſea; by this
did *Amphion* the *Dircean* gather together ſtones for building the *Theban*
walles. By this did *Timotheus* the *Phrygian* ſo enflame *Alexander Magnus*,
the Conquerour of the whole world, that he riſe from the table where he ſat,
and called for his armes; and afterwards changing his *Moode* on the In-
ſtrument, did cauſe him to put off his armour, and ſit downe againe to ban-
quet. By this did *Dauid* the princely Singer, helpe *Saul* the King of Iſ-
rael, when he was vexed with an vncleane Spirit; by this, not onely the
great God, the maker of all things, but alſo the furies of the *Stygian* God
are delighted, appeaſed, and mitigated. For this is the Lady and Miſtreſſe of
all other Arts; which can delight both thoſe that be in *Plutoes* iuriſdiction,
and thoſe that abode in *Neptunes* fields; and thoſe that liue in *Iupiters* eter-
nally lightſome Manſions. This Art onely, leauing the earth, flyeth vp before
the

the tribunall feat of the higheft Iudge; where together with the Inftruments
of the Saints it foundeth, where the Angels and Archangels doe inceffant-
ly fing Hymnes to God, where the Cherubins, and Seraphins, cry with a
continuall voyce, *Holy, holy, holy.* Befides, no Art without Muficke can be per-
fect: wherefore *Pythagoras* appointed his Schollers they fhould both when
they went to reft, and when they awaked vfe Melodies. Befides, Muficke
doth gouerne and fharpen the manners and fathions of men. For euen *Nero*
whilft he gaue himfelfe to Muficke, was moft gentle, as *Seneca* witneffeth:
but when hee leauing of Muficke, and fet his minde on the Diabolicall
Art of Nicromancie, then firft began that fierce crueltie of his; then was he
changed from a Lambe to a Wolfe. and out of a moft milde prince tranf-
formed into a moft fauage beaft But leaft I digreffe too farre, and leaft we
proceede from vnknowne beginnings, I will briefly fet downe what this Mu-
ficke is. Therefore *Menfurall Muficke* is a knowledge of making Songs by fi-
gures, which are in forme differing, and hauing the quantity of *Moode, time,*
and *Prolation:* Or it is an Art, whofe Harmony is effected by the variety of
figures and voyces.

<div align="center">

THE SECOND CHAPTER.

Of the Figures.

</div>

 Herefore a *Figure* is a certaine figne which reprefents a voyce,
and filence. A Voyce, (I fay) becaufe of the kindes of Notes
which are vfed: Silence, becaufe of the Refts which are of equall
value with the Notes, and are meafured with Artificiall Silence.

<div align="center">

Of the number of the Figures.

</div>

THe Ancients obferued onely fiue *Figures*, as principall Figures,
and fuch as receiue the quantitie of the three Degrees of Muficke:
Out of which after ages haue drawne out others for quicknetfe fake, accor-
ding to that faying of *Ouid:*
<div align="center">

Ex alys alias reparat natura figuras.

</div>
The bodies of the *Figures* are of the forme following.

A *Large* is a figure, whofe length is thrife as much as his breadth, ha-
uing on the part toward your right hand a fmall tayle, bending vpward, or
downeward.

A *Long* is a Figure, whofe length is twife as much as his breadth, hauing
fuch a tayle as the *Large* hath.

A *Breefe* is a Figure, which hath a body foure-fquare, and wants a tayle.

A *Sembreefe* is a Figure, which is round in forme of an egge, or (as *Fran-
chinus* fayeth) Triangular.

A *Minime* is a Figure like a *Sembreefe*, hauing a tayle, afcending or def-
cending.

A *Crochet*, is a Figure like a *Minime* in colour varying.

<div align="center">

M 2 A

</div>

A *Quaver* is a figure like a *Crochet*, hauing a dash to the right hand-ward.

A *Semiquaver* is a figure like a *Quaver* which hath two dashes, and therby is distinguished from it, as thus:

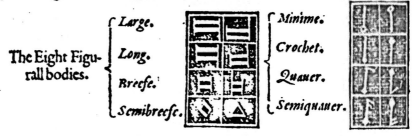

The Eight Figurall bodies.
{ *Large.*
Long.
Breese.
Semibreese. }

{ *Minime.*
Crochet.
Quaver.
Semiquauer. }

There is a certaine Figure, in shape like a *Minime*, but ioyned with the number of Three, which is called *Sesquialterata*, becaufe three are fung for two.

Befides, a Figure which hath two tayles, is as if it had none, becaufe one doth hinder another.

THE THIRD CHAPTER.

Of Ligatures.

Herefore a *Ligature* (as *Gaff.* writes in the fift chap. of his fecond Booke) is the conioyning of fimple Figures by fit ftrokes. Or (according to the ftrokes vpward or downward) it is the dependence of the principall figures in ftraightneffe, or crookedneffe.

Generall Rules for the Ligatures.

Firft, There are foure ligable Notes, that is a *Large*, a *Long*, a *Breefe*, and a *Semibreefe.*

2 Euery ligable Note, except a *Large*, may be figured with a two-fold body, a fquare body, and a crooked.

3 Euery ligable Note is to be iudged according to the afcenfion and defcenfion, either of it felfe, or of the Note following.

4 Euery ligable Note is either beginning, middle, or finall.

5 The Accidents of fimple Notes, fay for example, *alteration, imperfection*, and the like (as *Franchinus* witneffeth) are alfo the Accidents of the bounden Notes.

Rules for the beginning Notes.

Firft, Euery Beginning (whether ftraight, or crooked) wanting a tayle, when the fecond Note defcends, is a *Long.*

2 Euery Beginning Note without a tayle, if the fecond Note afcend, is a *Breefe.*

3 Euery Beginning Note hauing a taile downe-ward on the left fide of it, is a *Breefe.*

4 Euery Initiall, howſoeuer faſhioned, hauing a taile on the left ſide vp-ward, is a *Semibreeſe*, together with the Note next following; ſo that you need not care whether it aſcend, or diſcend.

Rules for the middle Ligatures.

F Irſt, Euery Note betwixt the firſt and the laſt, is called middle.

2 Euery middle Note howſoeuer ſhaped, or placed, is a *Breeſe.*

3 A *Long* may begin and end a *Ligature*, but can neuer be in the middle of it.

4 A *Breeſe* may be in the beginning, middle, and end of a *Ligature* very fitly.

5 A *Semibreeſe* may be in the beginning, middle, and end of a *Ligature*: ſo that it haue a taile in the left part vpward.

Rules for the finall Ligatures.

F Irſt, Euery laſt Note that is ſtraight, and deſcends, is a *Long*.

2 Euery Finall Note that is ſtraight, and aſcending, is a *Breeſe*.

3 Euery crooked Finall whether it aſcend or deſcend, is a *Breeſe*.

4 A *Large* whereſoeuer it is ſet, is alwaies a *Large*.

The Examples of theſe Rules are in the following *Tenor* ſet out.

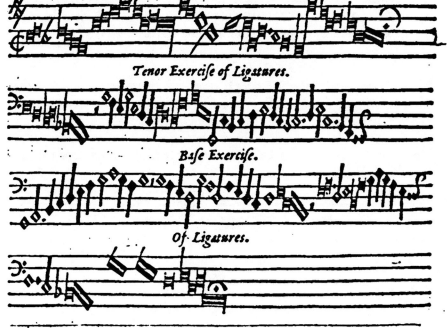

Tenor Exerciſe of Ligatures.

Baſe Exerciſe.

Of Ligatures.

The Fovrth Chapter.

Of Moode, Time, and Prolation.

He degrees of Muſick, by which we know the value of the principal figures, are three: to wit, *Mood*, *Time*, and *Prolation*. Neither doth any of them deale vpon all Notes, but each onely with certaine

Notes that belong to each. As *Moode* dealeth with *Largs,* and *Longs* ; *Time,* with *Breefes* ; *Prolation,* with *Semibreefes.*

A *Moode* (as *Franchinus* saith in the second Booke, *cap.* 7. of his *Pract:*) is the measure of *Longs* in *Largs,* or of *Breefes* in *Longs.* Or it is the beginning of the quantitie of *Largs* and *Longs,* measuring them either by the number of two or the number of three. For euery Figure is measured by a double value.

To wit, by the number of $\begin{cases} Two, \\ Three, \end{cases}$ and so is called $\begin{cases} Perfect, \\ Imperfect, \end{cases}$ because we make 3. perfect, and limit the imperfect by 2.

Of the Diuision of Moode.

Moode (as it is here taken) is two-fold: to wit, The greater, which is in the *Largs* and *Longs,* and the lesser, which is in the *Longs* and *Breefes.* And each of these is diuided into the perfect and imperfect.

Of the greater Moode.

THe greater perfect *Moode* is, when a *Larg* containes in it three *Longs:* or it is the measuring of three *Longs* in one *Larg.* The signe hereof is a perfect circle accompanied with the number of three, thus ; O3. The greater imperfect is a *Larg,* comprehending in it two *Longs:* which is knowne by an imperfect circle, ioyned to the number of three, thus ; C3.

Of the lesser Moode.

THe lesser perfect *Mood* is a *Long* hauing in it three *Breefes.* Or it is the measuring of three *Breefes* in one *Long,* whose signe is a perfect Circle, accompanied with the number of 2, thus ; O2. But the lesser imperfect, is a *Long* which is to be measured onely with two *Breefes.* The signe of this is the absence of the number of 2. Or a *Semicircle* ioyned to a number of 2. thus ; C2. O. C. as followeth :

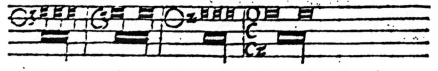

Of Time.

TIme is a *Breefe* which containes in it two or three *Semibreefes.* Or it is the measuring of two or three *Semibreefes* in one *Breefe.* And it is two-fold, to wit, perfect: and this is a *Breefe* measured with three *Semibreefes.* Whose signe is the number of three ioyned with a Circle or a Semicircle, or a perfect Circle set without a number, thus ; O3. C3. O. The imperfect is, wherein a *Breefe* is measured onely by two *Semibreefes.* Which is knowne by the number of two ioyned with a perfect Circle, or a Semicircle, or a Semicircle without a number, thus ; O2. C2.

Of Prolation.

Wherefore *Prolation* is the essentiall quantitie of *Semibreefes*: or it is the setting of two or three *Minims* against one *Semibreefe*. And it is twofold, to wit the greater (which is a *Semibreefe* measured by three *Minims*, or the comprehending of three *Minims* in one *Semibreefe*, whose signe is a point inclosed in a signe thus, ⊙ €) The lesser *Prolation* is a *Semibreefe* measured with two *Minims* onely, whose signe is the absence of a pricke. For *Franchinus* saith, They carry with them the imperfecting of the figure, when the signes are wanting, thus:

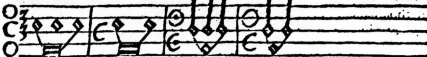

Time perfect. Imperf. time. Greater Prol. Lesse Prolation.

There was one well seen in this Art, that made this vnderwritten Example of these three degrees, reasonable learnedly and compendiously for the help of yong beginners : which (by his fauour) wee will not thinke vnworthy to set downe here.

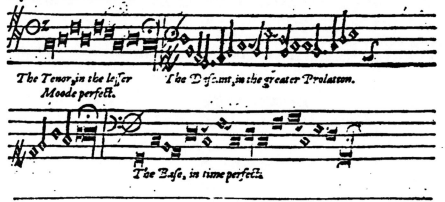

The Tenor, in the lesser The Descant, in the greater Prolation.
Moode perfect.

The Base, in time perfect.

THE FIFT CHAPTER.

Of the Signes.

Though there be such dissention betwixt Musitians about the Signes, such confusion of rules and examples, that euen to a perfect Musitian they seeme to breed doubts : so that *Plutarch* (a man furnished with all learning) saith in that Booke, which hee wrote of Musicke: In our time, the forme of difference hath so much increased, and so farre varied from the Custome of our Auncestors, that there is no mention, no precept, no certaintie of Art left. And also though wee be not to make a definitiue sentence in doubtfull matters, but rather to hold question: yet that yong beginners, which are desirous to learne this Art, may not be either discouraged from proceeding, or misled, leauing those things

which more vnufuall, wee will briefly fhew thofe things which are in vfe a-
mongft thofe Mufitians, who now are in credite : by feeking out that doubt
of the circle and number, which was among the *Theoricks.* Therefore a figne
is, a certaine figure fet before a Song, which fheweth the *Moode, Time,* and
Prolation.

Of the Diuifions of Signes.

OF Signes fome be principall, and fome leffe principall : The principall
are thofe, which are fit for the vnderftanding of *Moode, Time,* and *Prola-*
tion. And they are two-fold, to wit, *Extrinfecall,* and *Intrinfecall : Extrinfecall*
are thofe called, which doe outwardly prefent themfelues, and fhew the de-
grees of Muficke, as *Number,* a *Circle,* and a *Point.*

Rules for the Extrinfecall Signes,

FIrft, A Circle fet alone by it felfe fheweth time : if it be perfect it fhewes
perfect time, if imperfect, imperfect time. When it is ioyned to a num-
ber, it fignifies the *Moode.*

 2 A *Circle* accompanied with the number of 3. doth reprefent the grea-
ter *Moode,* but ioyned with a number of 2. the leffer.

 3 Wherefoeuer is the greater *Mood,* there is the leffe, but not contrarily.

 4 The number of three ioyned to a Circle, is a figne of the perfect time:
but the number of two, of the imperfect.

 5 A point inclofed in a figne of time noteth the greater *Prolation,* thus:

	O3	} of the greater *Moode*	{ Perfect	} of the perfect time.	
	C3		{ Imperfect		
Of Signes, fome be	O2	} of the leffer *Moode*	{ Perfect	} the time imperfect.	
	C2		{ Imperfect		
	⊙	} the greater *Prolation*	{ Perfect	} Time.	
	⊝		{ Imperfect		
	O	} Time	{ Perfect	} in the leffer *Prolation.*	
	C		{ Imperfect		

 But when out of the mingling of three principall Signes, to wit, of the
number, circle, and *point,* there be diuers fignes made, that you may the eaf-
lier haue the knowledge of them, and euery figure may haue his value, I
thought good in this forme following to fet downe a Table, by which you
might at firft fight iudg of the value of any figure, thogh placed in any figne.

A Resolutorie Table, shewing the value of the Signes by the beholding of euery figure.

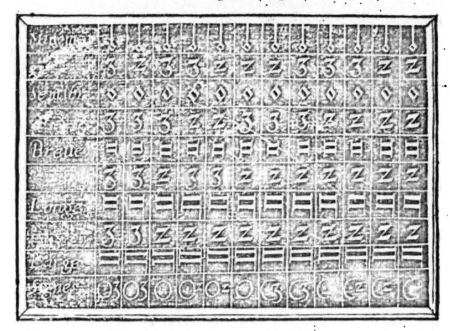

Of the Intrinsecall Signes.

THe *Intrinsecall* signes are those, by which the perfection of Musicall degrees in the figures is shewed, without the adioyning of any of the *Extrinsecall* Signes. Of these there are three, to wit;

1. The inuention of a rest of three times. For when in a Song, there is found a Rest which toucheth three spaces, it signifies the lesse perfect *Moode.* If it touch two, it sheweth the greater perfect. For saith *Franchinus*; It is not vnfit, that two Rests of three Times be adioyned to the greater *Moode*, if one be adioyned to the lesser.

2. The blacking of the Notes. For as oft as you find three *Longs* coloured, the lesser perfect *Mood* is signified. When three *Breefes*, the perfect time. When three coloured *Semibreefs*, the greater Prolation.

3. The doubling of certaine Rests. For as oft as two *Semibreefe* Rests are placed with a *Semibreefe*, the perfect Time is signified. So by two *Minims* with a *Min. me Note*, the greater Prolation, thus;

The greater *The lesser* *Time perfect.* *The greater* *Prolation.*
Moode. *Moode.*

Of the leʃʃe principall Signes.

THe Signes leʃʃe principall are thoʃe, which are not neceʃʃary for the knowledge of *Moode,Time,*and *Prolation.*And theʃe are diuers, as you may plainely ʃee in the quadrate following.

Repetition. Conueni- Concordance Aʃpiration.b Moll.Dealbation.
 ence. Cardinalis.

The Sixt Chapter.
Of Taʃt.

Herefore *Taʃt* is a ʃucceʃʃiue motion in ʃinging, directing the e-qualitie of the meaʃure:Or it is a certaine motion, made by the hand of the chiefe ʃinger,according to the nature of the marks, which directs a Song according to Meaʃure.

Of the Diuiʃion of Taʃt.

TAct is three-fold, the greater, the leʃʃer, and the proportionate. The greater is a Meaʃure made by a ʃlow,and as it were reciprocall motion. The writers call this *Taʃt* the whole,or totall *Taʃt.*And,becauʃe it is the true *Taʃt* of all Songs,it comprehends in his motion a *Semibreeʃe* not dimini-ʃhed : or a *Breeʃe* diminiʃhed in a duple.

The leʃʃer *Taʃt*,is the halfe of the greater,which they call a *Semitaʃt.* Be-cauʃe it meaʃures by it motion a *Semibreeʃe*, diminiʃhed in a duple : this is allowed of onely by the vnlearned.

The Proportionate is that, whereby three *Semibreeʃes* are vttered againʃt one,(as in a Triple)or againʃt two,as in a *Seʃquialtera.*Of this we ʃhall ʃpeake more at large in the Chapter of proportions.

A Rule for Taʃt.

A *Semibreeʃe* in all Signes(excepting the Signes of Diminution, augmen-tation,and proportions)is meaʃured by a whole *Taʃt*,as in the example following appeareth:

						4.or to one ʃtroake.	8.to one ʃtroake.	16.to one ʃtroake.	
⊙3	27	9	3	1					The Table of Taʃt reʃolued.
O3	27	9	3	1	½				
C3	12	6	3	1	½				
⊙2	12	6	2	1					
⊙	12	6	3	1					
C	8	4	2	1					
O	12	6	3	1	½				
C	8	4	2	1	½				

The Seventh Chapter.

Of Augmentation.

BEcause in the Chapter before going, we haue made mention of *Augmentation* and *Diminution*, therefore least we proceed from vnknowne things, we will shew what each is.

Therefore *Augmentation* is the making of more Notes in a Song: or it is the excrement of some Note. For in it is put a *Minime* for a *Semibreese*; a *Semibreese* for a *Breese*; a *Breese* for a *Long*.

By what signes you shall know Augmentation.

OF *Augmentation* therebe 3. Signes. The first is, the fewnes of the Notes in one part of the Song.

The second is, the adioyning of the *Canon*, by saying, Let a *Breese* be a *Large*, let a *Semibreese* be a *Long*, let a *Minime* be a *Breese*. Or let it increase in *Duplo, Triplo, vel hexagio, &c.*

The third is, a point in the Signe of time, found onely about one part of the Song : One I say, for if it be found about all, it is not a signe of *Augmentation*, but of the greater *Prolation*.

Rules of the Augmention.

FIrst, *Augmentation* is the contradiction of *Diminution*.

2 In *Augmentation* the *Minime* figure is measured with an whole *Tact*.

3 Betwixt *Prolation* and *Augmentation*, there is this difference, *Augmention* sounds one *Minime* to a *Tact*; *Prolation* sounds three, that is a perfect *semibreese* : which then is measured with a proportionate *Tact*.

4 The Rests are diminished and augmented, as well as the Notes.

5 *Augmentation* must seldome be, but in the Tenor.

6 A *Large* is not augmented, because it hath none greater than it selfe, whose value it may assume. Therefore they are in an errour, which say there are 81. *Tacts* in a *Large* which is set vnder such a signe ⊙3 : because a *Large* neither growes to aboue 27. *Tacts*, nor admitteth any thing greater than it selfe, because it is the greatest, than which there is nothing greater. Besides as in nature, so in Art it is in vaine to place a nothing : therefore should a *Large* be in vaine augmented, because no Song was euer found of so long time, that 81. *Tacts* might be Sung in an Vnison.

7 *Augmentation* comprehends vnder it selfe all the kinds of Notes excepting a *Large*, for which point marke the example following :

Augmentation. The greater Prolation. The Bariton or Base,

vnder the signe of Semiditie. *The greater Prolation.*

What a Canon is.

BEing we haue made mention of a *Canon*, least I hold the learner in a mammering, I will shew what a *Canon* is.

A *Canon* therefore is an imaginarie rule, drawing that part of the Song which is not set downe out of that part, which is set downe. Or it is a Rule, which doth wittily discouer the secrets of a Song. Now we vse *Canons*, either to shew Art, or to make shorter worke, or to try others cunning, thus;

THE EIGHT CHAPTER.

Of Diminution.

Diminution, which is more truely called *syncopation*, is the varying of Notes of the first quantity, as writeth *Fran. li. 2. Pr. 14.* Or it is a certain cutting off of the measure. For as in Grammer we say *secla* for *secula*, so in Musicke we do curtall the naturall and essentiall measure of the Notes by this *syncopation*. Therefore generally it shall be called *syncopation*, not *Diminution*, because it is a kind of *syncopation*.

Of the kindes of Syncopations.

OF this there be two kindes; *Semiditie*, and *Diminution*. *Semiditie* is the middle of the chiefe measure of Notes, which can be placed onely in an imperfect time, which hath these Signes, O2. C2. ₵. ℂ. ₵.

For in all these, the halfe of the measure is put off by the dash properly, and by the number, for so much as it hath of Duple proportion. Therefore *Erasmus Lapicida* doth well in placing one number vnder another in all these signes; thus; O$\frac{2}{1}$. C$\frac{2}{1}$.

For proportion is the relation of two quantities, not of one, as elsewhere we will more largely shew.

Of Diminution.

Diminution (as the Ancients thought) is the taking away of the third part from the measure. But the opinion of the Modernes, is more true and laudable, which make no difference betwixt *Diminution* and *Semiditie*, as *Ioan: Tinctoris*, of all that euer excelled in Musicke the most excellent writer,

writer, and *Franchinus Gafforus lib.2.cap.14.* haue positiuely set downe.

Therefore *Diminution* is the cutting off of the halfe part in the measure, nothing differing from *semidit ie,* but that it is found in perfect Signes, and in figures which are to be measured by the number of 3. Wherefore I cannot but scorne certaine Componists (for so they will be called) though indeed they be the Monsters of Musicke) who though they know not so much as the first Elements of the Art, yet proclaime themselues, The *Musitians* or *Musitians,* being ignorant in all things, yet bragging of all things, and doe (by their foolish toyes which contrarie to the maiestie of the Art, they haue gotten an habite of, rather by vse, than wit) disgrace, corrupt, and debase this Art, which was in many ages before honoured, and vsed by many most learned, (and to vse *Quintitians* words) most wise men: vsing any Signes at their pleasure, neither reckoning of value, nor measure, seeking rather to please the eares of the foolish with the sweetnesse of the Ditty, than to satisfie the iudgement of the learned with the maiestie of the Art. Such a one know I, that is now hired to be Organist in the Castle at *Prage,* who though he know not (that I may conceale his greater faults) how to distinguish a perfect time from an imperfect, yet giues out publikely, that he is writing the very depth of Musick: and is not ashamed to say, that *Franchinus* (a most famous writer, one whom he neuer so much as tasted of) is not worth the reading, but fit to be scoffed at, & scorned by him. Foolish bragging, ridiculous rashnes, grosse madnes, which therfore only doth snarle at the learned, because it knows not the means how to emulate it. I pray God, the Wolfe may fal into the Toiles, and hereafter commit no more such outrage; nor like the Crow brag of borrowed feathers. For he must needs be counted a Dotard, that prescribes that to others, the Elements whereof himselfe neuer yet saw. As *Phormio* the Greeke Orator (in *Tullies* second Booke *de Orat.*) who hauing before *Antiochus* the King of *Asia,* (in the presence of *Hanibal*) made a long Oration of the dutie of a Generall, when as hee himselfe had neuer seene Campe, nor armes, and had made all the rest to admire him, in the end *Hanibal* being asked, what his Iudgement was of this Philosopher, his answere was, That hee had seene many doting old men, but neuer any man that doted more, than *Phormio.* Now come I to the matter, and leaue these vnlearned ridiculous *Phormio's,* many whereof (the more is the shame) haue violently inuaded the art of *Musick,* as those which are not compounders of Harmonies, but rather corruptors, children of the furies, rather than of the Muses not worthy of the least grace I may doe them. For their Songs are ridiculous, not grounded on the Principles of the Art, though perhaps true inough. For the Artist doth not grace the Art, but the Art graceth the Artist. Therefore a Componist doth not grace Musicke, but contrarily: for there be that can make true Songs not by Art, but by Custome, as hauing happily liued amongst singers all their life-time: yet do they not vnderstand what they haue made, knowing that such a thing is, but not what it is. To whom the word our Sauiour vsed on the Crosse, may be well vsed; *Father pardon them, they know not what*

P *they*

they doe. Wherfore allow of no Componifts, but thofe, who are by Art worthy to be allowed of: now fuch are *Ioan. Okeken, Ioan: Tinctoris, Loyfet, Verbonet, Alex: Agricola, Iacobus Obrecht, Iofquin, Petrus de Larue, Hen: Ifaack, Hen: Finck, Ant: Brummel, Mat: Pipilare, Geor: Brack, Erafmus Lapicida, Cafpar Czeys, Conradus Reyn,* and the like : whofe Compofitions one may fee doe flow from the very fountaine of Art. But leaft by laughing at thefe fellowes we grow angry, and by being angry grow to hate them, let vs euen let them alone, and returne to *Diminution.*

Whereof we will refolue with *Franchinus* and *Tinctor,* that it taketh not away a third part, as the Ancients thought, (for it is hard finding out that) but one part : for as this figne ₵ . is the Duple of this figne C. fo is this ⊘ of this O. Wherfore euen approued Componifts doe erre, becaufe they mark not that there is a double Progreffion of meafure in a perfect Circle diuided with a dafh, befides the *Ternarie* number of the figures, becaufe they are of a perfect time : finging one *Semibreefe* to a *Tact,* when they fhould fing 2. For in that figne the Song is fo to be placed, that keeping the perfection of the *Ternarie,* it may receiue the Clofes, and end in a Binarie meafure. For in this Signe ⊘ . the Notes keepe the fame value, which they haue in this O, but the meafure onely, is to be meafured by the Binarie number, thus :

A Table for the Tact of Dimination.

Ø	6	3	Z	X				
Ø	6	3	Z	X	4. or. to one ftroake.	8. to one ftroake.	16. to one ftroake.	32. to one ftroake.
O²	6	3	1	X				
₵	4	Z	1	X				
₵	4	Z	1	X				
(Z)	4	Z	1	X				

By what fignes Diminution is marked.

NOw *Diminution* is marked by three wayes, to wit : By a *Canon,* by a *Number,* and by a *Dafh.* By a *Canon,* faying; It decreafeth in *Duplo, Triplo,* and *Quadruple,* and fuch like.

By a *Number,* for euery number adioyned to a Circle, or a Semicircle, befides that which effentially it betokens, doth alfo diminifh according to the naming of his figure. As the number of 2, being placed with a whole Circle befides the time, which it betokens to be imperfect, doth alfo fignifie a duple *Diminution,* the number of three a Triple, the number of foure a Quadruple, and fo forth.

By

By a *Dash,* to wit, when by a *Dash,* the signe of Time is diuided, thus; ₵.
₵.₵.₵.

Rules of Syncopation.

Irst, *Syncopation* belongeth to the measure of Time, not to the figures themselues.

2 *Syncopation* doth respect both the Notes, and the Rests.

3 *Syncopation* doth not take away the value, but the measure of the Notes.

4 The number doth not diminish *Prolation,* because it cannot work vppon the pricke, whilst a Circle doth keepe it.

5 Betwixt *Diminution* and *Semiditie,* there is no difference of *Tact,* or *Measure,* but onely of nature.

6 *Diminution* is the contradiction of *Augmentation.*

7 It is not inconuenient, that to the same Signe there may belong a double *Diminution,* to wit; *virgular* and *numerall,* thus; ₵2.

8 *Virgular Syncopation* is much vsed, *Numerall* seldome, *Canonicall* most seldome : the Example therefore following is of the first, and the second.

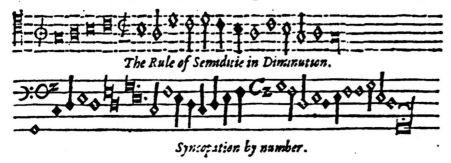

The Rule of Semiditie in Diminution.

Syncopation by number.

THE NINTH CHAPTER.

Of Rests.

Rest (as *Tinctoris* writeth) is the Signe of Silence. Or (as *Gaffarus* saith) it is a figure which sheweth the Artificiall leauing off from singing: Or it is a stroke drawne in line and space, which betokens silence. Now *Rests* are placed in songs after three manners, to wit ; Essentially, Iudicially, and both wayes. Essentially, when they betoken silence. Iudicially, when they betoken not silence but the perfect *Tact:* and then their place is before the signe of Time. Both wayes, when they represent both.

Rules for the Rests.

Irst, There be as many kinds of *Rests,* as of Notes.

2 The *Rest,* which toucheth all the spaces is generall, where all the voyces cease together, and is onely to be placed in the end.

3 The reſt which takes vp three ſpaces, is called of the *Moode*, which it betokens, and is to be placed onely in a perfect *Moode*.

4 A *Reſt*, which doth conclude two ſpaces, is called an imperfect *Long*.

5 A *Reſt*, which takes vp but one ſpace, is a *Breeſe* betokening one Time: whether perfect or imperfect.

6 A *Reſt*, deſcending from the line to the middle of the ſpace, is called a *Semibreeſe*.

7 A *Reſt*, aſcending from the line to the middle of the ſpace, betokens a *Minime*, or a ſigh.

8 A *Reſt*, like a ſigh, being forked to the right hand-ward, betokens a *Crochet*.

9 The *Reſts* of the two laſt figures, becauſe of their too much ſwiftneſſe, are not in vſe among Muſitians.

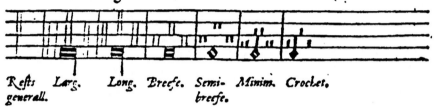

Reſts *Larg.* *Long.* *Breeſe.* *Semi-* *Minim.* *Crochet.*
generall. *breeſe.*

The Tenth Chapter.

Of Prickes.

WHerefore a *Pricke* is a certaine indiuiſible quantity, added to the Notes, either for *Diuiſion*, or for *Augmentation*, or for *Certainty* ſake. Or it is a certaine Signe leſſer than any other accidentally ſet either before, or after, or betweene Notes.

Of the Diuiſion of a Pricke.

OVt of this Definition, there are collected three kindes of *Prickes*, to wit: That of *Addition*, and that is the *Augmentation* of the figures. Or it is the perfection of imperfect Notes. This is ſet in the middle on the right ſide, and is found onely in imperfect Signes, and doth augment the Notes to which it is added, the halfe of his owne value, as in the Example following appeareth.

Tenor point of Addition. The Baſe is the ſame.

Of the Pricke of Diuision.

THe *Pricke* of Diuision is the disioyning of two Notes, neither taking away nor adding any thing, but distinguishing two Notes by reckoning the first with the former, & the second with the following Notes, to the end that the *Ternarie* perfection in Notes may be had. Here the *Pricke* in perfect degrees, is ioyned not to perfect figures, but to their neere parts, neither is adioyned to the middle of the side, as that of Ad. ition, but a little higher, or lower about the middle of the Notes, which it diuides, thus:

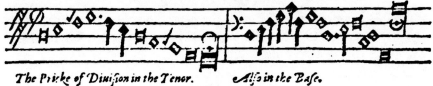

The *Pricke of Diuision in the Tenor.* *Also in the Base.*

Of the Pricke of Alteration.

THe *Pricke* of *Alteration*, was obserued more by the Ancients, than the later Mufitians. Yet least it may breed some doubt to the Singer, that shall light on it by chance, it is not amisse to speake somewhat of it. Therfore the *Pricke* of *alteration* is the repeating of Notes, which doth accidentally befall them, not as they are perfect, but as their parts neighboring the perfect. Now is it set neither on the one side, nor vpward, nor downe-ward, but directly ouer the Note, which it alters, as in this Example appeareth.

The *Pricke of Alteration in the Tenor.* *Also in the Base.*

There are besides these, two other kindes of *Prickes*, to wit, of perfection. And this is a *Pricke* set after a perfect Note ; neither increasing nor diminishing it, but onely preseruing it from being imperfected by the following Note. It is set as the *Pricke* of Addition, but differs from it, because it is alwayes, and onely placed about perfect Notes.

There is another *Pricke* of *Transportation*, adioyned to Notes, which it doth tranflate to be reckoned with figures remooued further off: and this doth direct his force not vpon the precedent Notes, but onely vpon the following ones, thus;

The *Pricke of perfection or Transportation in the Tenor.*

Also in the Base.

The Eleventh Chapter.

Of Imperfection.

 Herefore *Imperfection* is the degrading of perfect Notes. For to imperfect is to make a perfect Note imperfect. Or it is this, to bring it from his value.

Of two-fold Imperfection.

Imperfection is two-fold : to wit, *Totall*, when precisely the third part of the value is taken from the Notes : as when in perfect time a *Breefe* is imperfected by a *Semibreefe*. Or partiall, when not precisely the third part, but a lesse than that, say a sixt part, or so, is taken from the Notes: as when a long of the imperfect *Moode*, but in the perfect time, where it is valued at two *Breefes*, is imperfected by a *Semibreefe*, in regard of the *Breefe* in it contained : and as a *Breefe* by a *Minime* in the greater *Prolation*.

By what Signes Imperfection is knowne.

OF *Imperfection* there be three Signes, (as writeth *Franchinus li.2.Pract. cap.11.*) to wit, numerall *Imperfection*, punctuall *Diuision*, and *fulnesse* of the Notes.

Rules of Imperfection.

First, There is foure Notes which may be imperfected, to wit, a *Larg*, a *Long*, a *Breefe*, a *Semibreefe*.

2 Euery figure, which may be imperfected, is alway to be considered in the number of his perfect quantitie.

3 That which is once imperfect, cannot be more imperfected.

4 Euery figure that may be imperfected, is greater than the imperfecting figure.

5 *Imperfection* is made not onely by the neere parts of the Notes, but also by the remoued parts. As a perfect *Breefe* can be imperfected, not onely by a *Semibreefe*, which is the neere part, but also of two *Minims*, which are remote parts of it.

6 Two neighbouring parts of one perfect figure doe not imperfect it, but onely one : although two remoued ones may doe the same. Wherefore if you finde two *Semibreefe* Rests after a perfect *Breefe*, it shall remaine perfect, vnlesse punctuall Diuision come betweene.

7 Euery

7 Euery leſſe figure being ſuperfluous doth imperfect the greater going before, not the following one : vnleſſe it happen by reaſon of the *Pricke* of *Diuiſion*, *Perfection*, or *Tranſportation*.

8 A Note of one ſort comming before his like is not imperfected, wherby euery figure that is to be imperfected, muſt be put before a figure that is greater, or leſſe than it ſelfe.

9 The greater Note doth not imperfect the leſſe, nor an equall Note an other equall Note.

10 The figure which doth imperfect another figure, takes ſo much from it, as it ſelfe is valued at.

11 A *Reſt* is not imperfected, but doth imperfect.

12 A *Ligature* doth neuer imperfect, but is imperfected.

13 A *Larg* doth nothing, but ſuffereth onely in *Imperfection*.

14 A *Minime* doth, and neuer ſuffereth in *Imperfection*.

15 A *Long*, *Breeſe*, and *Sembreeſe* doe imperfect, and are imperfected.

16 Euery *Imperfection* is either before or behinde: Before, as when the imperfecting Note doth goe before the Note that is imperfected: Behind, as when it followeth. There be that thinke it is cauſed both wayes in partiall *Imperfection*.

17 That *Imperfection*, which is cauſed before and behind, is cauſed not by the neighbouring, but by the remote parts.

18 All *Imperfection* is cauſed either by the Note, the Reſt, or the colour. By the Note, to wit, when a figure of a leſſer kind is placed before or after a perfect Note, and ſo imperfects it, thus:

Tenor. Baſe.

By a *Reſt*, to wit, when a *Reſt* of a leſſe kind is found before or after a perfect Note: but the *Reſt* cannot be imperfected, as thus:

Tenor.

Baſe.

By Colour: when in the perfect figures you finde Colour, the Notes are Imperfect ; becaufe their third part is taken away, thus :

Tenor.

Baffus and his Pofition.

Of Colour.

Wherfore *Colour* in this place is nothing, but the fulnes of the Notes: Or, it is the blacking of the principall figures: the force whereof is fuch, that it takes away the third part of the value from figures placed in their perfect quantitie: and from imperfects fometime it takes away the fourth part, fometimes it makes them of the *Hemiola* proportion. Wherefore I thought good to place here a Table of the perfect figures coloured. Wherein note this, that the voide fpaces doe fhew that that figure, ouer which they are placed, is not to be coloured in that figne. But the Sphærical figure (which the learned call the figure of nothing) declares that the figures may be coloured, yet that they haue not the value of one *Tact.*

Colour being in other figures effentiall, induce no accidentall quantity into Notes.

☉3	18	6	Z	o	o
O3	18	6	Z	1	
☉Z	8	4	Z	o	o
OZ	4	Z	1		
☉	8	4	Z	o	o
Ø	4	Z	1	o	o
O	8	4	Z	L	
Ø	4	Z	1	o	
	♩	♩	♯	♦	↓

Colour is oftentimes found among most of the learnedst, neither to take away nor to adde any thing: but specially, when to remoue *Alteration*, it is placed in the neighbouring parts of perfect figures, thus:

Tenor. Base.

Most commonly the *Colour* doth cause a Duple proportion in the imperfect figures, (as *Franchinus* saith. *lib.2. cap.*11.) which *Henry Isaack* in a certaine *Alleluia* of the Apostles, did thus both wittily, and truely dispose.

Tenor. Base.

The Twelfth Chapter.

Of Alteration.

Lteration according to *Ioannes de Muris*, is the doubling of a lesser Note in respect of a greater, or (as *Tinctor* saith) it is the doubling of the proper value. Or it is the repetition of one, and the selfe-same Note. And it is called *Alteration*, *Quasi altera actio*, it is another action, to wit: A secundary singing of a Note, for the perfecting of the number of three.

Rules of Alteration.

Irst, There be foure Notes, which may be altered, (saith *Franchinus lib. 2. cap.*13.) a *Long*, a *Breefe*, a *Semibreefe*, and a *Minime*.

2 *Alteration* doth exclude the *Larg*, and is limitted by a *Minime*, because a *Larg* hath not a greater than it selfe, whose neighbouring part it may be: and the lesse figures are not to be reckoned after the number of three.

3 *Alteration* happens in numbers which be not perfect, but are parts neighbouring to perfect Notes, because a perfect Note in as much as it is a perfect Note is not lyable to *Alteration*.

4 Onely the Notes are altered, not the *Rests*.

5 *Alteration* falleth vpon the second Note, not vpon the first.

6 Euery altered Note containeth it selfe twise.

7 A like Note is not altered before a like Note.

8 *Alteration* onely fals out in perfect degrees.

3 *Alteration*

9　*Alteration* comes for want of one Note, when you haue reckoned after the *Ternary* numbring.

13　As oft as two alterable Notes are placed betwixt two imperfectible Notes without a *Pricke* of Diuision : the second is always altered, as the Example following doth shew.

11　If a *Reſt* together with the figure, to which it is of equall value, bé encloſed betwixt 2. perfect notes; thé either the reſt goes before the figure, or followes it; if the Reſt go before, the figure is altered : if otherwiſe, there is no place for *Alteration*, becauſe the notes only are altered, & not the Reſts. Beſide *Alteration* fals alwayes vpon the ſecond, and not vpon the firſt, thus :

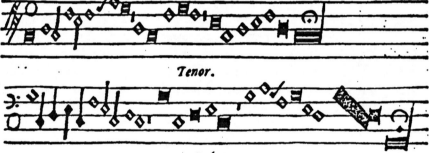

12　*Alteration* is taken away by the fulneſſe of the notes, and by the *Pricke* of Diuiſion. In *Ligatures* alſo *Alteration* is kept, as in the following Example is cleere.

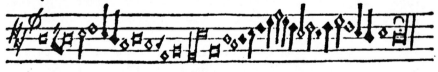

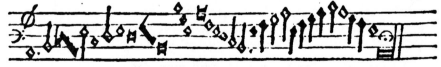

13　As oft as three alterable Notes are ſlatt within two imperfectible Notes,

Notes, both the imperfectible shal remaine perfect, and none of the alterable Notes is altered: because the *Ternarie* number is euery where perfect.

- - - - - - - - - -

THE THIRTEENTH CHAPTER.

Of Proportion.

Herefore *Proportion* is the nature of two compared together in one vniuocall thing. Vniuocall I say, because in æquiuocals there is no comparison: for a still and a loud voice are not compared. Whence is it, that proportion is properly called, when it is found in those things, which are equall and vnequall, like and vnlike. Or according to *Euclide*; it is a certaine disposition of two quantities how bigge soeuer, (being of the same next *Genus*) one to the other. Hence is it that things continuate and discreate, although they be contained vnder the same *Genus* of quantitie, yet are not compared, because they are remote, not neere.

- - - - - - - - - -

Of the Diuision of Proportion.

Roportions are some of equality, some of inequalitie. That of equalitie is the Relation of two equall quantities. For that is equall, which is neither greater, nor lesse than his equall. That of inequalitie, is the disposition of two vnequall quantities. For that is called inequall, which being in Relation with another is either greater or lesser than it.

- - - - - - - - - -

What Proportion is fit for Musitians.

Ecause the dissimilitude, and not the similitude of voyce doth breede Harmonie: therefore the Art of Musicke doth onely consider of the *Proportion* of inequalitie. This is two-fold: to wit, the *Proportion* of the greater or of the lesse inequalitie The *Proportion* of the greater inequalitie, is the relation of the greater number to the lesse, as 4.to 2.6.to 3. The *Proportion* of the lesser inequalitie is contrarily the comparison of a lesse number to greater, as of 2.to 4. of 3.to 6.

- - - - - - - - - -

Of the 5. kindes of Proportions.

OF the *Proportions* of the greater inequalitie, there be 5. Kindes, to wit; *Multiplex, Super particular, Super partiens,* and those be simple: the compounded are the *Multiplex Super particular,* & the *Multiplex Super partiens.*

To these are opposed 5. other kindes of the lesser inequalitie (saith *Franchinus*) and hauing the same names with the Preposition *Sub,* onely set before them: as *Submultiplex,* &c.

But seeing that *Multiplex Proportio* hath chiefe force in Musicall Consonances, and next to that the *Super particular,* and the *Super partiens* with the two following none, we doe therefore abandon the *Super partiens* with the

rest following, as vnworthy of the Harmonicall Consort, and doe receiue the two formost onely.

Of the *Multiplex* kinde.

THe *Multiplex Proportio*, is both more excellent, and more ancient than the rest, as when a greater number being in Relation with a lesse, doth precisely comprehend the whole lesser number more than once, as say, twise, or thrise. The kindes of this will be infinite, if you compare each number with an vnitie, as in the following quadrate you may see.

Z	3	4	5	6	7	8	9	10
1	1	1	1	1	1	1	1	1

Dupla. Trip. Quadru. Quintu. Sextu. Septu. Octup. Nonu. Decū.

To this foresaid kinde is opposed the first kinde of the lesser Inequalitie, called *Submultiplex*. The one of these destroyeth the other; and this kind, making the same Relation of an vnitie to other numbers, doth produce out of it selfe the same *Species* which a *Multiplex* doth, and *Species* of the same names, by adding the Preposition *Sub*, and is produced in this manner.

1	1	1	1	1	1	1	1	1
Z	3	4	5	6	7	8	9	10

Sub dup. Sub trip. Sub quadr. Sub quintu. Sub sextu. Sub septu. Sub octu. Sub nonu. Sub decū.

Of the *Superparticular* Kinde.

SVperparticular, the second kinde of *Proportions* is, when the greater number being compared with the lesse, doth comprehend it in it selfe once, & besides some such part of it. Some such part (I say) which being often taken doth make precisely the whole greater number. Of this kinde the sorts are innumerable, if you reckon each of the numbers, taking away an vnity, with the next lesser, in manner following.

3	4	5	6	7	8	9	10	
Z	3	4	5	6	7	8	9	

Sesqui altera. Sesqui tertia. Sesqui quarta. Sesqui quinta. Sesqui sexta. Sesqui septima. Sesqui octa. Sesqui nona.

The opposite to this, is *Subsuperparticular*, the second kind of the lesse Inequalitie: which doth produce the same *Species*, which the former doth, with the same names, the Preposition (*Sub*) being adioyned: if you will compare each of the lesser numbers (an Vnitie I alwayes except) with the greater neighbouring, as here followeth the manner.

2	3	4	5	6	7	8	9	
3	4	5	6	7	8	9	10	

Subſeſquialtera.	ſubſeſquiterta.	ſub'ſeſquiqnarta.	ſubſeſquiquinta.	ſubſeſquiſexta.	ſubſeſquiſeptima.	ſub'eſquiocta.	ſubſeſquinora.

By what meanes Proportion is made of æqualitie, and conſequently one Proportion out of another.

WHen you will make a *Proportion* out of Equalitie, and one proportion out of another, you ſhall thus truely worke it by this Rule of *Boëtius,* Diſpoſing three equall numbers, ſay vnities, or any other, let three other be placed vnder them, ſo that the firſt may be euen with the firſt; the ſecond with the firſt, and the ſecond; the third, with the firſt; the two ſeconds, and the third, and you ſhall find it a *Duple,* thus:

1	1	1	2	2	2	3	3	3
1	2	4	2	4	8	3	6	12

 Duple. *Duple.* *Duple.*

Now if you wil make *Triples,* placing the *Duples,* which you haue made in the higher ranke, let three numbers be placed vnderneath, according to the Tenor of the foreſaid Rule, and you haue your deſire; thus:

1	2	4	2	4	8	3	6	12
1	3	9	2	6	18	3	9	27

 Triple. *Triple.* *Triple.*

Now if we place theſe *Triples,* which we haue thus found in the vpper ranke, we ſhal produce *Quadruples,* by the concordant, and regular oppoſition of the numbers vnwritten, of *Quadruples, Quintuples;* and alſo out of *Quintuples, Sextuples,* and ſo forward infinitely.

1	3	9	1	4	16	1	5	25
1	4	16	1	5	25	1	6	36

 Quadruple. *Quintuple.* *Sextuple.*

And if out of *Duples,* you will create *Seſquialteræs,* inuerting the numbers of the *Duples,* ſo that the greater may be firſt, and the leſſer ſucceed in a naturail order: let there be vnder placed three other numbers, as often as the ſaid Rule requireth, and you haue that, as followeth.

4	Z	1	8	4	Z	1Z	6	3
4	6	9	8	1Z	18	1Z	18	Z1

 Sesquialtera. *Sesquialtera.* *Sesquialtera.*

Now as of *Duples* you make *Sesquialteraes*, so of *Triples* you may make *sesquitertiaes*, and of *Quadruples sesquiquartaes*, by conuerting the numbers, as was said of *sesquialteraes*, and so you may goe infinitely, in manner following.

9	3	1	16	4	1	Z5	5	1
9	1Z	16	16	Z0	Z5	Z5	30	36

 Sesquitertia. *sesquiquarta.* *sesquiquinta.*

Out of what Proportions Musicall Concords are made.

THe *Proportions*, which make Musicall Consonances, are sixe, (as *Boëtius* and *Macrobius* witnesse) three in the *Multiplex* Kind, to wit, the *Dupla*, *Tripla*, *Quadrupla*: 3 in the *super particular*, to wit; *sesquialtera*, *sesquitertia*, & *sesquioctaua*. Of which specially the allowed Interuals of Musicke are compounded (as saith *Plutarch*.) Where relinquishing others, wee thought fit to make plaine by short precepts and examples these only, which consist and are deicribed in Notes. So keeping the naturall order, we will begin with the *Dupla*, because it is both worthyer and better knowne, than the rest.

Of the Duple Proportion.

DVpla *Proportio*, the first kind of the *Multiplex*, is when the greater number being in relation with the lesse, doth comprehend it in it selfe twise: as 4. to 2: 8. to 4. But Musically, when two Notes are vttered against one, which is like them both in nature and kinde. The signe of this some say is the number of 2: others (because *Proportion* is a Relation not of one thing, but of 2) affirme that one number 〈 2.4.6. 〉 is to be set vnder another, thus, And make no doubt but in all 〈 1.2.3. 〉 the rest this order is to be kept.

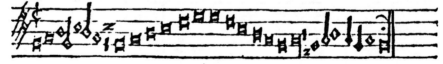

Tenor Duple.

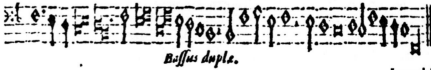

Bassus duple.

I would

I would not haue you ignorant, that the duple *Proportion*, and all the other of the *Multiplex* kind, are marked by certaine Canons, saying thus, *Decrescit in duplo, in triplo,* and so forth. Which thing because it is done either to increase mens diligence, or to try their cunning, wee mislike not. There be that consider the whole *Proportion* in figures, which are turned to the left hand-ward with signes, and crookes, saying, that this C. is the duple of this Ↄ. and this ⌐ of ⌐ and in Rests that this ⌐ is the duple of this ⌐ I thinke onely vpon this reason, that *Franchinus pract. lib.2.cap.4.* saith that the right side is greater and perfecter than the left: and the left weaker than the right. Against which opinion neither my selfe am. For in *Valerius Probus* a most learned Gramarian in his interpretation of the Roman letters saith, that the letter C. which hath the forme of a Semicircle signifies *Caius* the man, and being turned, signifies *Caia* the woman. And *Fabius Quintilianus* in approouing of *Probus* his opinion saith; for *Caius* is shewed by the letter C. which being turned signifies a woman: and being that men are more perfect than women, the perfection of the one is declared by turning the Semicircle to the right hand, & the weaknesse of the other by turning it to the left. By this occasion the Musitians thought fit to take away the halfe left side from the right, thus; ⌐ ⌐ Ↄ C ⌐⌐

Rules of Proportions.

FIrst, Euery *Proportion* is either taken away by the comming of his contrary proportion, or is broken by the interposition of a signe. As by the comming of a *subduple,* a *dupla* is taken away, and so of others.

2 Euery *Proportion* respecteth both Rests and Notes.

3 Euery *Proportion* of the great Inequalitie doth diminish the Notes and Rests with his naturall power: but the *Proportion* of the lesse Inequalitie doth increase them.

4 *Alteration* and *Imperfection* are onely in those *Proportions*, which are in perfect degrees, neither are they in all figures, but in those onely, which those degrees doe respect with their perfection, or to which these accidents besides the *Proportion* doe belong.

5 The *sesquialtera Proportion* doth exclude the *Ternarie* perfection of figures, vnlesse they haue it from a signe. Wherefore when the signe denies it; they receiue neither *Alteration,* nor *Imperfection.*

Of the Triple.

THe *Triple Proportion,* the second kinde of the *Multiplex* is, when the greater number, being in Relation with the lesse, doth comprehend it in it selfe 3. times, as 6. to 2: 9. to 3. But Musically, when three Notes are vttered against one such, which is equall to it in kind. The signe of this is the number of three set ouer an Vnitie, thus;

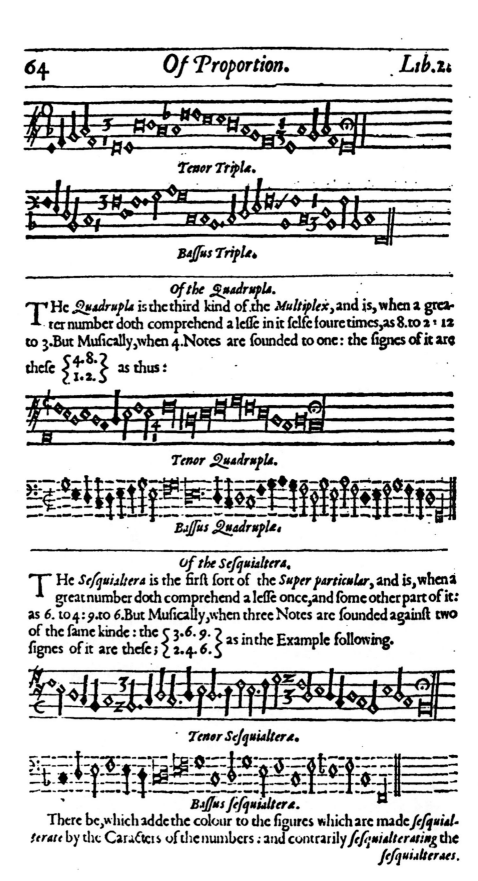

Tenor Tripla.

Baßus Tripla.

Of the Quadrupla.

THe *Quadrupla* is the third kind of the *Multiplex*, and is, when a greater number doth comprehend a leſſe in it ſelfe foure times, as 8.to 2 : 12 to 3.But Muſically,when 4.Notes are ſounded to one: the ſignes of it are theſe $\{{4.8.}\atop{1.2.}\}$ as thus :

Tenor Quadrupla.

Baßus Quadrupla.

Of the Sesquialtera.

THe *Seſquialtera* is the firſt ſort of the *Super particular*, and is, when a great number doth comprehend a leſſe once,and ſome other part of it: as 6. to 4 : 9.to 6.But Muſically,when three Notes are ſounded againſt two of the ſame kinde : the ſignes of it are theſe ; $\{{3.6.9.}\atop{2.4.6.}\}$ as in the Example following.

Tenor Seſquialtera.

Baßus ſeſquialtera.

There be,which adde the colour to the figures which are made *ſeſquial-terate* by the Caraċters of the numbers : and contrarily *ſeſquialterating* the
ſeſquialteraes.

sesquialteraes. And these men (as *Franchinus* witnesseth) haue this fault, that they make of two *sesquialteraes*, not a duple *sesquialtera*, (as they thinke) but a duple *sesquiquarta*. Some put *Imperfection & Alteration* in the *sesquialterates* of the imperfect time, mesuring a *Breefe* Rest with one Tact: although in the Notes they set 3 *semibreefes* in one Tact. But vpon what ground they doe it, excepting of an Asse-headed ignorance, I know none. For *Imperfection* admits not the *Imperfection* and *Alteration* of signes, neither doth *Proportion* exclude Rests.

Of the Sesquitertia.

THe *Sesquitertia* Proportion, which they cal *Epitrite*, becaufe it is made by an *Epitrite*, *Macr.* faith, it is when the greater number of Notes, doth containe the lefler in it felfe, & befides his third part: as 4.to 3:8 to 6:12.to 9. But. Mufically, when 4. Notes are founded againft 3. which are like themfelues. The fignes of it are thefe, ⸂4 8.12. ⸃ There be that afcribe an inuerted *femicircle* to this *Proportion*, ⸃ 3. 6. 9. ⸂ but *Tinctor* feemes to be againft that.

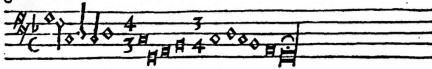

<div align="center">*Tenor sesquitertia.*</div>

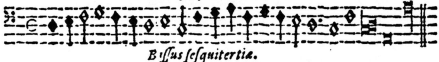

<div align="center">*Bassus sesquitertia.*</div>

Of the sesquioctaua.

THe *sesquioctaua* Proportion is, when a greater number being compared with a lefle, doth comprehend it once, and with it his 8 part, as 9.to 8: 18 to 16. But Mufically, when 9. Notes are fung to 8, which are like themfelues. The figne of it is the number of 9. fet ouer 8, thus; ⸂9 ⸃ *Or* ⸂8 8⸃

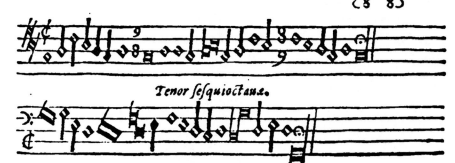

<div align="center">*Tenor sesquioctaua.*</div>

<div align="center">*Bassus sesquioctaua.*</div>

<div align="right">There</div>

There are besides, who (because the value is diminished by adioyning the colours)doe consider the *Sesquialtera* by the fulnes of the Notes;which also they call *Hemiola.* For *Hemiola* is that,which *Sesquialtera* is, faith *Aulus Gellius lib.19.cap.*14. Yet this blacking of the Notes, is accidentall to it neuer, but vnder the imperfect quantitie, as *Franchinus* writeth.

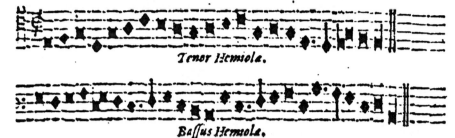

Tenor Hemiola.

Bassus Hemiola.

Though there be many other kindes of *Proportions,* which the Mufitians doe obferue in Harmonicall *Concent,* yet haue I omitted all thefe for briefenefle fake, leaft children(for whom this Booke is made) fhould haue their wits rather clogged than helped hereby. Therefore the learned may pardon me, becaufe this is written for them that are hungry, not for thofe that haue a delicate mawe.Yet (by the grace of God)all that now for breuitie fake,or vpon other occafions I now omit, fhall be painefully fet downe in a greater volume with more diligence and care. Meane while, I intreat yong men to exercife themfelues with thefe fmall precepts,that when they are to goe to higher matters they may be fit.

The end of the fecond Booke.

TO PHILIP SVRVS OF MIL-
TENEVEGH A SHARP-WITTED MAN, MASTER OF
Art, and a most cunning *Musitian*, Chappel-Master to the Count
Palatine the Duke of *Bavaria: Andreas Ornithoparchus* of
Meyning, sends greeting.

OSt deere Philip, in that a man is the most worthy of all Creatures, a creature made like to God, by nature milde, of stature upright, provident, wise, of memory, witty, by reason, susceptible of Lawes and learning; by his Creatours great gift, farre preferred before all unreasonable Creatures in all things, but specially in two, to wit, Speech and Reason; it followes that Ignorance in him is so much the fowler fault, by how much hee is more worthy than other Creatures. Now this, as it is a fowle shame for all men, so for Schollers it is the fowlest disgrace: the course of whose life is ordayned for this, that by living well they may shew others an example of good fashions, learning and honesty, encreasing fervent Faith in the people, and, which is their chiefest Office, by praising God in Hymnes and songs, stirring up devotion in the hearts of the faithfull.

By observation whereof, most kinde friend, I was stirred up to helpe learners in that kinde also, and after the handling of Concent, which in the former bookes we have delivered, to deliver the Ecclesiasticall Accent. A matter surely hard, because it requires both a Grammarian and a Musitian, and also because it is to be had rather by use than by writing: and further because either none or very few men have handled this point: by this difficulty the worke was a while hindered from seeing the light; now being set out and perfected, I commit it to your tuition, and subiect it to your censure, beseeching you both to mend the errours you find in it, and to defend it from the invasion of envious men: because thou art able, learned, godly, and besides other gifts of nature, hast an elegant stile, a sweet vaine, and in singing a gracefull cunningnesse, wherin thou doest exceed thy fellow-Musitians, in entertaining strangers (as I to your cost found) a liberall humour. Whence it is come to passe, that all the Masters of the Budorine university, which they call Heydelberg, do singularly love, honour, and respect you. Farewell, (worthy Sir) and defend thy Andreas from the envious backebiter.

T 2 THE

THE THIRD BOOKE OF ORNI-

TOPARCHVS HIS *MVSICKE,* TOVCHING THE *ECCLESIASTICALL ACCENT.*

The Argument of Master *Choterus* vpon the Third Booke.

THE FIRST CHAPTER.

In Praise of Accent.

 Ccent hath great affinitie with *Concent,* for they be brothers: becaufe *Sonus,* or *Sound,* (the King of Ecclefiafticall Har-mony) is Father to them both , and begat the one vpon Grammar; the other vpon *Muficke,* whom after the Father had feene to be of excellent gifts both of body and wit, and the one not to yeeld to the other in any kind of knowledge, and further that himfelfe (now growing in yeeres) could not liue long, he be-gan to thinke, which he fhould leaue his kingdome vnto; beholding fome-time the one, fometime the other, and the fafhions of both. The *Accent* was elder by yeares, graue, eloquent, but feuere : therefore to the people leffe pleafing. The *Concent* was merry, frollicke, liuely, acceptable to all, defiring more to be loued, than to be feared : by which he eafily wonne vnto him all mens minds. Which the Father noting, was daily more and more troubled, in making his choyfe. For the *Accent* was more frugall, the other more plea-fing to the people. Appointing therefore a certaine day, and calling toge-ther the Peeres of his Realme, to wit, Singers, Poets, Orators, morall Philo-fophers, befides Ecclefiaftical Gouernors, which in that Function held place next to the King, before thefe King *Sonus* is faid to haue made this Oration: My noble Peeres, which haue vndergone many dangers of warre, by land and fea, and yet by my conduct haue caried the Prize throughout the whole world; behold, the whole world is vnder our Rule, wee haue no enemy, all things may goe profperoufly with you; only vpon me death increafeth, and life fadeth, my body is weakned with labor, my foule confumed with Care, I can expect nothing fooner than death. Wherfore I purpofe to appoint o e of my Sonnes Lord ouer you, him (I fay) whom you fhall by your common voyces choofe, that he may defend this Kingdome, which hath been pur-chafed with your blood, from the wrong and inuafion of our enemies.

When he had thus faid, the Nobles began to confult, and by companies to handle concerning the point of the common fafety ; yet to difagree, and fome to choofe the one, fome the other. For the Orators and Poets would

haue

haue the *Accents*, the Mufitians, and the Moralifts chofe the *Concent*. But the Papale Prelates, who had the Royalties in their hands, looking more deepely into the matter, enacted that neither of them fhould be refufed, but that the kingdome fhould be diuided betwixt them, whofe opinion the King allowed, and fo diuided the Kingdome, that *Concentus* might be chiefe Ruler ouer all things that are to be fung (as *Hymnes, Sequences, Antiphones, Refponfories, Introitus, Tropes*, and the like: and *Accent* ouer all things, which are read; as Gofpels, Lectures, Epiftles, Orations, Prophecies. For the Functions of the Papale kingdome are not duely performed without *Concent*. So thefe matters being fetled each part departed with their King, concluding that both *Concent* and *Accent* fhould be fpecially honoured by thofe Ecclefiafticall perfons. Which thing *Leo* the Tenth, and *Maximilian* the moft famous Romane Emperour, both chiefe lights of good Arts, (and fpecially of *Mufike*) did by generall confent of the Fathers and Princes approoue, endow with priuiledges, and condemned all gaine-fayers, as guilty of high Treafon; the one for their bodily; the other for their fpirituall life. Hence was it, that I marking how many of thofe Priefts, (which by the leaue of the learned I will fay) doe reade thofe things they haue to read fo wildly, fo monftroufly, fo faultily, that they doe not onely hinder the deuotion of the faithfull, but alfo euen prouoke them to laughter, and fcorning with their ill reading) refolued after the doctrine of *Concent* to explaine the Rules of *Accent*, in as much as it belongs to a *Mufitian*, that together with *Concent*, *Accent* might alfo as true heire in this Ecclefiafticall kingdome be eftablifhed. Defiring that the praife of the higheft King, to whom all honour and reuerence is due, might duely be performed.

The Second Chapter.

Of the Definition, and Diuifion of Accent.

Herefore *Accent* (as *Ifidorus lib.* 1. *eth. cap.* 17. writeth) is a certaine law, or rule, for the rayfing, or low carrying of fillables of each word Or, it is the Rule of fpeaking. For that fpeaking is abfurd, which is not by *Accent* graced. And it is called *accent*, becaufe it is *ad Cantu*, that is, clofe by the fong, according to *Ifidore*: for as an aduerbe doth determine a Verbe, fo doth *accent* determine *Concent*. But becaufe thefe defcriptions doe rather agree with the Grammaticall *accent*, than with the Muficall, I hold it neceffary to fearch out by what means the Ecclefiafticall *accent* may rightly be defcribed. Therefore *accent* (as it belongeth to Church-men) is a melody, pronouncing regularly the fyllables of any words, according as the naturall *accent* of them requires.

Of the Diuifion of accent.

NOw it is three-fold, as *Prifcian* and *Ifidore* witneffe, the *Graue*, the *Acute*, and the *Circumflex*. The *Graue* is that, by which a fillable is carried low:

but to speake musically, it is the regular falling with finall words, according to the custome of the Church. Of which there be two sorts. One which doth fall the finall word, or any syllable of it by a fift: and this is properly called *Graue*. Another which doth fall the finall word, or any syllable of it onely by a third, which by the Musitians is called the middle *Accent*. Neither haue the Grammarians cause to be angry, if they find any thing here contrary to their lawes. For we goe not about to handle the Grammaticall *Accent*, which *Priscian*, and others haue throughly taught, but the Ecclesiasticall, as here followeth:

Medius.　　　　　　　　**Grauis.**
Parce mihi domine, nihil enim sunt dies mei.

An *acute Accent* grammatically, is that, by which the syllable is raised. But musically, it is the regular eleuation of the finall words or syllables according to the custome of the Church. Wherof there are likewise two kinds: one which reduceth the finall syllable or word to the place of his discent, keeping the name of *Acute*. The other, which doth raise the second sillable not to the former place of his discent, but into the next below. Which is also called *Moderate*, because it doth moderately carry a sillable on high, as appeareth in the example following:

Moderatus.　　　　　　　　　**Acutus.**
Illuminare Hierusalem quia gloria domini super te orta est.

The *Circumflex* is that, by which a sillable first raised is carried low. For it is, as *Isidore* witnesseth, contrary to the *acute*, for it begins with the *acute*, and ends with the *graue*, vnknowne to Church-men. Yet the Monkes, and especially those of the Cistertian order, haue the *Circumflex accent*, as at the old Cell a Monastery of the same order my selfe haue tried, and I my selfe haue seene many of their bookes in the same place.

Now farewell they that forbid Church-men to vse Musicke; what solace (setting singing aside) can they haue either more healthfull, or more honest? For whilst we recreate our selues with singing, all euill thoughts, and speech, all backe-biting, all gluttony and drunkennesse, are auoyded. Wherefore Song-Musicke both plaine and Mensurall, becommeth the most religious, that they may both sing praises to God, and make themselues merry at fit times of recreation. But leauing this discourse, let vs returne thether whence we digressed, and send those which would busily enquire the nature of the *Circumflex accent*, to *Mich. Gallieulus*, who hath set out the matter so briefly, that it need no other explayning.

The

THE THIRD CHAPTER.

Of the generall Rules of Accent.

Ecause to proceed from easie things to harder, is the naturall method, we thought fit first to explaine the generall Rules of accent, and secondly the speciall.

1 Euery word of one syllable, or indeclinable, or barbarous, requires an *acute accent* : as *Astarot, Senacherib, me, te, sum.*

2 Greeke and Hebrew words in Latine terminations retaine the Latine accent, as *Parthenopolis, Nazarenus, Hierosolima.*

3 Greeke and Hebrew words hauing not the Latine Declension, are acuted, as *Chryson, Argyrion, Ephraim, Hierusalem.*

4 A *graue accent* is made in the end of a complete sentence, an *acute* likewise, the *Moderate* and *Meane* onely in the end of an imperfect sentence.

5 A *graue accent* must not be repeated, if no other come betwixt, vnlesse the speech be so short, that another cannot come betwixt, as thus:

Factum est vespere & mane dies secundus dixit quinque Deus.

THE FOVRTH CHAPTER.

Of the speciall Rules of Accent.

Irst, A word that is of one sillable, indeclinable, barbarous, or Hebrew, which wee saide must haue an *acute accent*, either is in the end of a compleat sentence, and is thus acuated ; or in the end of a sentence not compleat, and is thus. From this Rule are excepted Encletical Coniunctions, which are marked with a *graue Accent*, thus:

Dominus locutus est de monte ad me & ego exaudiam vos Deus dominusque

2 The first sillable of a word which hath two sillables, doth alwaies receiue the *accent*, whether it be short or long, thus:

Et fugit velut vmbra. Et in amaritudinibus moratibitur oculus meus.

3 A word of many sillables put in the end of a speech, either hath the last saue one Long or Short : if Long, the *accent* fals vpon it, if short, then the last saue two receiues the *accent*.

Lignum si praecisum fuerit rursum virescit. Et rami eius pullulant.

4 A speech with an interrogation, whether it haue in the end a word of one sillable, or of two sillables, or more, the *Accent* still fals vpon his last sillable, and that must be acuated. Now the signes of such a speech are, *who, which, what,* and those which are thence deriued, *why, wherefore, when, how, in what sort, whether,* and such like.

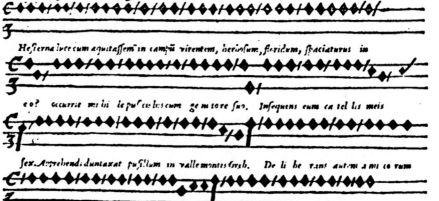

Vnde es tu Quid est homo? Quantas habe o in i qui tates & pecca ta?

To these are ioyned Verbes of asking as *I aske, I seeke, I require, I search, I heare, I see,* and the like.

The Fift Chapter.

Of the Points.

BEcause the Ecclesiasticall *accent* is commonly knowne by *Points,* it is necessary to deliuer the nature of certaine *Points* fitting this purpose.

1 The *Point,* which they call a *Dash,* if it be placed betwixt more words of one part of a sentence, it shewes they are to be reade distinctly.

2 Two Pricks, or one Prick set directly on the middle of the right side, is a marke of the middle *accent,* which discends by a third.

3 A Pricke in the end of any sentence raised a little aboue the middle, doth represent either the *acute,* or moderate *accent,* according as the sentence giues it.

4 A Prick a little below the middle of the word, is a marke of the *Graue accent.*

5 A *Point* of Interrogation, which is made thus (?) being found in some place, doth shew that the last sillable of the word, (to which it is ioyned) is to be pronounced with an *acute accent.* The euidence whereof followes in the example following.

Hesterna luce cum aquitassem in campu virentem, heriosum, floridum, spaciaturus in

eo? occurrit mihi lepusculus cum ge m tore suo. Insequens eum ca tel lis meis

sex. Aprehendi duntaxat pusillum in valle montis sitsih. De li be rans autem a mi co rum

Lc po ri as istas carnes essem von do na tu ru ? interrogans comitem meum quid esset

pealuturus?

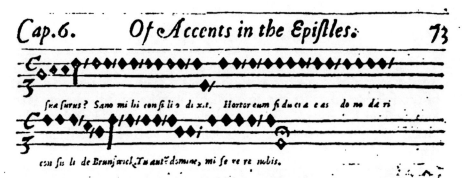

ſca ſurus? Sano mi hi conſi li a di x.t.　Hortor eum fi du ci a e as　do no da ri

con ſu li de Brunſwick, Tu aut dominé, mi ſe re re nobis.

The Sixt Chapter.

Of Accent in the Epiſtles.

THe totall *Accent* of Epiſtles is diuers, (according to the diuerſity of Dioceſſe and Religions) yet the partiall is the ſame withall, becauſe it proceeds from the quantitie of Sillables, as by the vnderwritten rules is cleere.

1　Euery *accent* of Epiſtles and Goſpels are taken out of the ſillables of the finall ſentences, and their number?

2　When in the end of a ſentence is placed a word of one ſillable, the accent is varied according to the varietie of the words going before.

3　If a word of one ſillab'e goe before the like finall word, and before it a third of the ſame ſort, the firſt is to be raiſed, thus :

Sic in fla ti ſunt quidam tanquam non ventu rus ſit ad nos.

Now by what meanes (according to the Monkes) that *accent* is diſtingui-ſhed, Friar *Michael de Maris Galliculus* in his Treatiſe, which hee wrote both truely and learnedly, hath worthily ſhewed.

4　If a word of two ſillables come before a word of one ſillable finall, then the firſt ſillable of it muſt be raiſed, whether it be long: or ſhort, thus :

Omnia enim veſtra ſunt ſi quis di li git de um ex e o eſt.

5　If a word of three ſillables come before a word of one ſillable finall, then is it to be raiſed, if it haue the laſt ſaue one *Long*: if ſhort, then the accent is to be tranſlated to the laſt ſaue two.

In pace Deus vocat vos. Diſpen ſa ti o ni in credita　eſt.

6　If a word of two ſillables be placed in the end of a ſpeech, then the laſt ſyllable ſaue one of the word going before muſt be raiſed, if it belong : If it be ſhort, the laſt ſauing two, thus :

Ex i vi de nu bi. Et in ple ni tu di ne Sanctui de ten ti o me a.

7 If a word of three syllables be placed in the end of a speech, and a word of one sillable goe before it, then this is to be raised : but if a word of two syllables, then let the first syllable of it be raised, whether it be long, or short. If a word of three syllables goe before a word of three syllables, it raiseth the last saue one, if it be long : If it be short, the last saue two, thus :

Tu scis om ni a nonne dix it do mi nus cantantes De o glori am.

.te il b. dix e runt domi no nouit em m a d'mi nus.

8 If in the end of a speech be placed a word of more syllables than three, then the first syllable of it must be raised, if it be long : if it be short, the *accent* fals vpon the word going before, thus :

Dix it. domi nus om nipotens in templo So lo mo nis sunt au rei pa ri e tes.

The Seventh Chapter.
Of the Accent of Gospels.

He totall *accent* of Gospels, is differing in diuers Diocesse and Religions. But the partiall, which is the same euery where, is comprehended in the Rules following.

1 If the speech end with a word of one syllable, and another goe before it, and a third before that, the *accent* is taken from the first, thus:

2 If a word of two syllables goe before a word of one finall, the first syllable of it receiues the *accent*, whether it be long or short, thus.

Surrexit non est hic. Om ni a ver ba hec. Do mi nus dedit hoc.

3 If a word of many syllables goe before a word of one syllable finall, the *accent* fals vpon his last syllable saue one, if it be long ; if it be short, vpon the last saue two.

Dolentes que re ba mus te nonne dix it om ni a hec.

4 If the speech end with a word of two sillables, the last sillable saue one of the word going before must be raised, if it be long ; if short, the last saue two, thus ‹

Vt de scri be retur ⁊ ni uer sis Or bis Abraham au tem ge nu it Iacob.

5 If the speech end with a word of three syllables, hauing the last saue one Long, then the *accent* fals vpon the last syllable of the word going before. But if it be short, then the last sillable saue one of it shall receiue the *accent*, thus:

Ex e a que su it V ri e. It clausa est is nu a.

6 If the finall word of a speech be of more syllables than three, the *Accent* fals vpon the first sillable of it, if it be long : if it be short, the last sillable of the word going before is raised.

In transmigratione Ba bi lo nis. Et fi li us al tis si mi vo ca bi tur.

Of the Accents of Prophecies.

THere is 2. waies for *accenting Prophesies.* For some are read after the maner of Epistles, as on the Feast daies of our *Lady,* the *Fpiphany, Christmas,* and the like, & those keep the *accent* of Epistles: some are sung according to the maner of Morning Lessons, as in Christs night, & in the *Ember* Fasts: and these keep the *accent* of those Lessons. But I wold not haue you ignorant, that in accenting oftentimes the maner and custome of the Country and place is kept; as in the great Church of *Magdeburgh, Tu autē Domine,* is read with the middle sillable long, by reason of the Custome of that Church, whereas other Nations doe make it short, according to the Rule. Therefore let the Reader pardon me, if our writings doe sometime contrary the Diocesse, wherein they liue. Which though it be in some few things, yet in the most they agree. For I was drawne by my owne experience, not by any precepts to write this booke. And (if I may speake without vain-glory) for that cause haue I seene many parts of the world, and in them diuers Churches both *Metropolitane* and *Cathedrall,* not without great impeachment of my state, that thereby I might profit those that shall liue after mee. In which trauell of mine I haue seen the fiue Kingdomes of *Pannonia, Sarmatia, Boemia, Denmarke,* and of both the *Germanies* 63. Diocesses, Cities 340. infinit fashions of diuers people, besides sayled ouer the two seas, to wit, the *Balticke,* and the great *Ocean,* not to heape riches, but increase my knowledge. All which I would haue thus taken, that the Readers may know this booke is more out of my experience, than any precepts.

The end of the Third Booke.

TO THE WORTHY AND INDVSTRIOVS, MASTER

Arnold Schlick, a most exquisit Musitian, Organist to the Count *Palatine*,
Andreas Ornithoparchus of *Meyning*, sends health.

Ere Arnold, *whereas mans intellect in it beginning is naked and without forme, and hath nothing in it, but a possibility to receiue formes, many haue doubted why the high Creatour did not giue knowledge naturally to man as well as to other sensible creatures. For some haue naturally the art of spinning; some of making hony; some of weauing; some of doing other things: but man is borne naked, vnarmed, without any Art, crying the first day of his birth, and neuer laughing til he be 40. dayes old (as* Pliny *writeth in the Prologue of the 7. booke of his* Nat. Hist.) *Is man therfore inferiour to beasts? in no sort, for that nakednes of man doth not argue his vnworthinesse, but his noblenesse. For that which is within, hinders not that which would be without. Hence is it, (we see) that those animals, which haue arts naturally, can doe nothing but that naturall Art. But man wanteth all Arts, that he may be fit for all: which is proued by the natural desire hee hath to knowledge. For Arts are desired by all, though they be not bought by all; and are praised by all, though they be not searched after by all. The hindrance is sloath, pleasure, vnorderly teaching, and pouerty. And though we haue naturally the desire of all Arts, yet aboue all we doe desire and loue the Art of Singing. For that doth entise all liuing things with the sweetnes; draw them with the profit; and ouercome them with the necessity of it: whose parts (thogh they be al both sacred & diuine) yet that which we cal the Counter-point, is more sweet, worthy, & noble, than al the rest. For this is the dwelling place of al the other, not that it cōtains in it al the difficulties of* Musicke; *but because to make it, it requires a learned and perfect Musitian. Wherfore hauing discussed of the rest, least our Office be fayling in this last point, I thought good to handle the Counter-point, placing it in the last place (as it were a treasury) wherin al the secrets of* Musick *are laid vp: not that hereby all men, to whom nature is not seruiceable, should fall to composition, but that all men may iudge whether those things which be composed by others, be good or bad. Yet whoso can, let them compose by our writings: they which cannot, let them proceed, as farre as they can.*

But not to digresse too wide, (worthy Sir) I haue in this last booke, collected the Rules of the Counter-point, out of diuers places, for the common good of learners; which I bring to you to be weighed, that after your censure, it may be subiected to the carps of the malicious. For from your sentence no man will euer appeale; because there is no man either learneder, or subtiler in this Art, than your selfe, who besides the practise hast wisdome, eloquence, gentlenesse, quicknesse of wit, & in al kinds of Musick *a diuine industry, and further the knowledge of many other sciences. Thou wantest the bodily lamp, but in thy mind shineth that golden light: thou seest nothing without thee, within thee thou seest al things. Thou wantest the cleerenesse of the eyes, thou hast the admirable quicknes of wit: thy sight is weak, thy vnderstanding strong; Wherfore not onely by thy princes, who are to thee most gracious, but euen of all men (like* Orpheus *and* Amphion) *art thou loued. Farewell, the honour and delight of* Musicke, *and protect thy* Andreas *from* Zoilisses *and* Thersitisses.

THE FOVRTH BOOKE
OF *ORNJTHOPARCHVS* HIS
Muficke, declaring the Principles of
the Counter-point.

The Argument of Mafter *Cotherus.*

THE FIRST CHAPTER.

Of the Definition, Diuifion, and difference of the names of the Counterpoint.

Itomachus the Mufitian faith, That the Art of *Mufcke* was at firft fo fimple, that it confifted of a *Tetrachord.* And was made with the voice *Affa,* that is, one Voyce alone (for *Affa* the Ancients called alone, whereof it is called *Vox affa,* when it is vttered with the mouth, not adding to it other Muficall *Concents,* wherein the praifes of the Ancients was fung, as *Phil. Beroaldus* writeth in the Tenth booke of his Commentary vpon *Apuleius.* Yet by the meanes of diuers authors, the *Tetrachord* from foure Cords grew to fifteen. To which the after-ages haue added fiue and fixe Voyces, and more. So that a Song in our times hath not one voyce alone, but fiue, fixe, eight, and fometimes more. For it is euident, that *Ioannes Okeken* did compofe a Mottet of 36. Voyces. Now that part of Mufick which effecteth this, is called of the Mufitians, the *Counterpoint.* For a *Counterpoint* generally, is nothing elfe than the knowledge of finding out of a Song of many parts. Or it is the mother of *Modulation,* or (as *Franchinus lib.* 3. *cap.* 1. writes) it is the Art of bending founds that may be fung, by proportionable Dimenfion, and meafure of time. For, as the clay is in the hands of the Potter; fo is the making of a Song in the hands of the Mufitian. Wherefore moft men call this Art not the *Counter-point,* but *Compofition.* Affigning this difference of names, and faying, that *Compofition* is the collection of diuers parts of Harmony by diuers *Concords.* For to compofe is to gather together the diuers parts of Harmony by diuers *Concords.* But the *Counter-point* is the fodaine, and vnexpected ordering of a plaine Song by diuers Melodies by chance. Whence *Sortifare* fignifies to order a plain Song by certain *Concords* on the fodaine. Now it is called *Counterpoint* (as *Bacchus* faith) as it were a concordant *Concent* of Voyces fet one againft another, examined by Art.

Y *of*

Of the Diuifion of the Counter-point.

THe *Counter-point* is two-fold : Simple and Coloured. The Simple *Coun-ter-point* is the concordant ordering of a Song of diuers parts by Notes of the fame kind. As when a plaine Note is fet againft a plaine Note, a *Breefe* againft a *Breefe*, thus :

Difcantus. *Tenor.* *Altus.* *Baffus.*

The Coloured *Counter-point* is the conftitution of a Song of diuers parts by diuers figures, and diffcring *Concords*, thus :

Cantus. *Tenor.* *Altus.* *Baffus.*

The Second Chapter.

Of Concords and Difcords.

Eing that *Concordance* (as faith *Boëtius*) is the due mingling of two or more voices, and neither can be made without a *Sound*, nor a *Sound* without *beating*, nor *beating* without *Motion*, it is neceffary *motion* be diuided. Of *motions* therefore fome be equall, fome vne-quall. Now it is plaine, that out of the equality of *Motions* doe proceed equall founds, and out of the inequality of it, vnequal founds : and out of the mean inequalitie doe proceed confonant Sounds, out of the greater inequalitie, *Difcords*. Hence is it, that the *Fythagoreans* concluded, that no *Concord* could be beyond the *Difdiapafon* (as before appeared *lıb.1. cap.5.*) becaufe of the too great diftance of the extreames. By how much therefore *Sounds* are neerer one another, they are fo much the fweeter? and the further they are diftant one from another, the leffe they agree. Which I doe chiefly proue to come by the inequall falling of fuch founds into the eares, becaufe a Con-fonance is a mixture of two Sounds, falling into the eares vniformely. For high Sounds are heard fooner, than bafe Sounds. As a fharpe Sword pier-ceth quicker, whereas a blunt one doth not fo, but enters flowly : euen fo when we heare an high forced Voyce, it ftrikes into one : but a bafe voyce doth dully, as it were thruft at one, faith *Cælius lıb.10.cap.53.*

Of Voyces.

BEcaufe the likeneffe of Voyces, doth not breed *Concord*, but the vnlike-neffe. Therefore Voyces are called fome *Vnifons*; fome not *Vnifons*. *Vni-fons* are thofe, whofe Sound is one. Not *Vnifons* are thofe, whereof one is
deeper,

deeper, another higher. Of not *Vnisons*, some are *æquisons*; some *Consones*; some *Emmeles*; some *Dissonant*. *Aequisons* are those, which being stroke together, make one sound of 2. as *Diapason* and *Disdiapason*. *Consones* are those, which yeeld a compound or mingled Sound, *Diapente* and *Diapason diapente*. *Emmeles* are they, which being not *Consones*, yet are next to *Consones*: as those which sound thirds, sixts, or other imperfect *Concords*. *Discords* are they whose Sounds mingled together, doe strike the sence vnpleasingly.

What Concord is.

BY that which hath been said appeares, that Consonance (which otherwise we call *Concordance*) is the agreeing of two vnlike Voyces placed together. Or is (as *Tinctor* writeth) the mixture of diuers Sounds, sweetly pleasing the eares. Or accoding to *Stapulensis lib.3.* It is the mixture of an high, and lowe sound, comming to the eares sweetly, and vniformely. Of which (among the Practickes) there are two vsed, although some by repeating the former, haue more.

Viz. $\begin{cases} \text{Vnison,} \\ \text{Third,} \\ \text{Fift,} \\ \text{Sixt,} \end{cases} \begin{matrix} 8 \\ 10 \\ 12 \\ 13 \end{matrix} \begin{cases} 15 \\ 17 \\ 19 \\ 20 \end{cases}$ *Vnisonum & eundem causant sonum, quia fiunt in octauis.*

Of Discords.

A *Discord* (as saith *Boëtius*) is the hard and rough thwarting of two sounds, not mingled with themselues. Or, (as *Tinctor* saith) it is the mixture of diuers sounds, naturally offending the eares, whereof there be Nine:

Viz. $\begin{cases} \text{Second,} \\ \text{Fourth,} \\ \text{Seuenth,} \end{cases} \begin{matrix} 9 \\ 11 \\ 14 \end{matrix} \begin{cases} 16 \\ 18 \\ 21 \end{cases}$ *Vnum & eundem causant sonum, quia fiunt in octauis.*

THE THIRD CHAPTER.

Of the Diuision of Concords.

OF *Concordances* some be simple or primarie, as an *Vnison*, a third a fift, and a sixt. Others are repeated or secundary; which are also *æquisons* to them that goe before, proceeding of a duple dimension. For an eight doth agree in sound with an vnison; a tenth with a third; a twelfth with a fift; and a thirteenth with a sixt. Others are tripled, to wit, a fifteenth, which is equall to the sound of an Vnison, and an Eight. A seuenteenth, which is equall to a third, and a tenth; a nineteenth which is equal to a fift, & a twelfth: a twentieth, which is equall to a sixt and a thirteenth, and so forth. Of *Concords* also some be perfect; some imperfect. The perfect are those, which being grounded vpon certaine Proportions, are to be proued by the helpe of numbers. The imperfect, as not being pro-

bable, yet placed among the perfects, make an Vnison sound; whose names are these:

The Perfects are $\begin{cases} \text{Vnison,} \\ \text{Fift,} \\ \text{Eight,} \end{cases}$ and $\begin{cases} 12 \\ 15 \\ 19 \end{cases}$ Imperfects are $\begin{cases} 13 \\ 17 \\ 20 \end{cases}$

Each whereof simply carryed, doth receiue onely two Voyces, although by corruption it receiue more.

Rules of Concords.

FIrst, Two perfect *Concords* of the same kinde, are not suffered to follow themselues, but Cords of diuers kindes may well. Yet an Eight, so that they proceed by different and contrary Motions, saith *Franchinus lib. 3. cap.3.* thus :

Discantus. Tenor.

2 Two imperfect *Concords* or more, are allowed to follow themselues together, ascending or descending.

3 Let alwaies the next perfect follow the imperfect *Concords*, as an Vnison after an imperfect third; a fift after a perfect; a fift after an imperfect sixt; an eight after a perfect, as *Gafforus lib.3.cap.3.*declareth.

4 Many perfect *concords* of the same kinde immouable are allowed to follow one another, but the moueable not.

5 A *Minime*, or his *pause* is not sufficient to come betwixt perfect *Concords* of the same kinde, because of the little, and as it were insensible sound it hath, although by most the contrary be obserued.

6 It may fall out so, that a *Minime* or a *Crochet*, may be a *concord* in parts contrarily proceeding, for such a *discord* is hidden, nothing at all offending the eares. Yet must you take heede, least two or more be ioyned together.

7 A *Breefe* or a *Semibreefe* discording, is banished from the *Counterpoint*. Yet be there, that admit a *Breefe* discordant diminished in a *Quadruple*, and a *Semibreefe* diminished in a *Duple*.

THE FOVRTH CHAPTER.

Of the generall Rules of the Counter-point.

FIrst, If you desire to compose any thing, first make the *Tenor*, or some other Voyce: according as the *Tone* by which it is ruled doth require.

2 The vnusuall *Moodes* are by all meanes to be auoyded: for they all are *Discords*, except the tenth.

3 In perfect Concordances neuer set a sharpe Voyce against a flat, nor
contrarily;

contrarily, but set a *Sharpe* against a *Sharpe* ; a *Flat* against a *Flat*, or at least against a naturall. For the Naturals are doubtfull, and will agree with ♮ *Dures*, and b *Mols*, thus ?

Tenor. *Bafe not good.* *Bafe is good.*

4 If the *Tenor* in the plaine Song goe too deepe, transpose it to a fift, or to a fourth if need be, as you may see in the *Hymne, Quem terra.*

5 All the parts of the Song in the beginning and end were by the ancients made of perfect Cords : which Rule with vs is arbitrarie.

6 When one Voyce goes vpward or downeward, you need not vary the rest : because to an immouable voyce, many mouable voices may be fitted.

7 In euery Song seeke for the neerest *Concords* : for they which are too farre distant, doe taste of *Discord*, say the *Pythagoreans.*

8 Let the *Tenor* together with the rest haue sweete *Melodie*, in wandring Collations.

9 If the *Tenor* touch the *Meanes* and *Trebles*, the *Meane* may descend to the place of the *Tenor.*

10 If the *Tenor* fall to touch the *Bafe*, let the *Bafe* goe vp into the place of the *Tenor*, according as the *Concords* shall require.

11 Euery Song, must be often adorned with formall *Closes.*

12 If the *Tenor* shall haue the Close of the *Meane*; the *Meane* on the other side shall haue the Close of the *Tenor*, by ending either from a tenth in an eight, or from a third in an Vnison, thus :

Difcantus. *Tenor.*

13 If the *Bafe* take the Close of the *Tenor*, the *Tenor* shall take the Close of the *Meane* ; Or if the *Bafe* take the Close of the *Meane*, the *Tenor* shall take his Close, as in the Rule going before is shewed, thus :

Tenor. *Bafe.*

14 The *Meane* doth seldome take a fift aboue the *Tenor* · but the imfect *Concordance* oft times.

15 The *Bafe* must seldome or neuer be placed in a sixt vnder the *Tenor*, vnlesse an Eight straight follow, but in the perfect *Concords* it may often.

16. If the *Base* haue a fift vnder the *Tenor*, let the *Meane* be set in a fift aboue the *Tenor*, by ending in a third, thus:

Discantus. *Tenor.* *Bassus.*

17. Let the *Meane* seldome leape by a fift vpwards, but by a sixt and an eight it may oft: to which also an eight downeward is forbidden, though all the other Interuals be graunted.

18. A *Base* may not leape a sixt, it hath all the other *Moodes* common.
—19. In Fourths *Mi* doth not agree with *Fa*, because it maketh a *Tritone*.

20. A Fourth though being simply taken it is a *Discord*, yet being ioyned to a *Concord*, and mingled therewith, it maketh a Concordant midling with the extreames, saith *Franchinus*.

21. A Fourth is admitted onely in two places in the *Counter-point*: first when being shut betwixt two Eights, it hath a fift below. Because if the fift be aboue, the *Concord* is of no force : by that reason of *Aristotles* (whom *Plato* calleth *Anagnostes*, that is an vnwearied Reader of Bookes) whereby in his Problemes he shewes, that the deeper Discordant sounds are more perceiued than the higher. Secondly, when the *Tenor* and *Meane*, doe goe by one or more sixts, then that Voyce which is midling, shall alwayes keepe a Fourth vnder the *Cantus*, and a third aboue the *Tenor*.

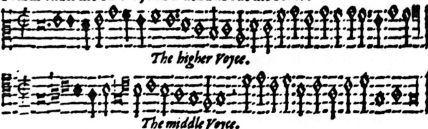

The higher Voyce.

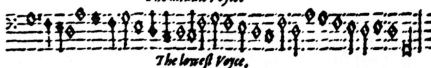

The middle Voyce.

The lowest Voyce.

21. The most famous manner of the *Counter-point*, 2. (saith *Franchinus*) is if the *Base* goe together with the *Meane*, or any other Voyce, being also distant by a sixt, which the *Tenor* doth giue in Concord to both, thus:

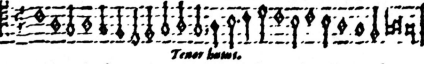

Tenor bassus.

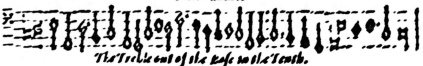

The Treble out of the Base to the Tenth.

23 If you ioyne not the fame Concord, you fhall make two parts Concords in Tenths.

24 It is neceffary for yong beginners to make a Scale of ten lines, then to diftinguifh it by bounds, fo that they may write each time within each bound, by keyes truly marked, leaft the confufed mingling together of the Notes hinder them; yet is it better to compofe without a Scale, but becaufe it is hard, let yong men begin with a Scale, thus:

Neither muft young learners thinke it a matter of no weight, how the fignes are fet together, for by the vnorderly referring of them, fo many errours haue fprung in Muficke, that it is hard to be knowne, in what path a man may goe fafe. Wherefore if a man will compare one figne with another, let him carefully marke the nature of the Diminution and Proportions, leaft referring this to that, the meafure of the one be too great, or too little.

THE FIFT CHAPTER.

Of the Parts and Clofes of a Song.

THe Ancient fimpleneffe of Muficke, knew not the diuers parts of a Song, which the fubtileneffe of our age requires. For the whole being encreafed, al the parts are increafed. Now the parts which Mufitians at this time vfe, are many, to wit; the *Trebie, Tenor,* high *Tenor, Melodie, Concordant, Vagrant, Contratenor, Bafe;* yea, and more than thefe. But becaufe they be not all commonly vfed, we will fpeak fomewhat of thofe which are moft commonly vfed; of the reft nothing.

Of the Difcantus.

THe *Difcantus* (as *Tinctor* faith) is a Song made of diuers voyces. For it is called *Difcantus, Quafi diuerfus Cantus*, that is, as it were another Song. By which name the ancients did call euery Menfurall Song. But we, becaufe *Difcantus* is a part of a fong feuered from the reft, will defcribe it thus. *Difcantus* is the vppermoft part of each Song. Or it is an Harmony to be fong with a Childs Voyce.

Of the Tenor.

A Tenor is the middle voyce of each Song, or (as *Gafforus* writes *lib.3. cap.5.*)it is the foundation to the Relation of euery Song: so called a *Tenendo*, of holding, because it doth hold the Consonance of all the parts in it selfe, in some respect.

Of the Baritone.

THe *Bassus*, (or rather *Basis*) is the lowest part of each Song. Or it is an Harmony to be sung with a deepe voyce, which is called *Baritonus, a Vari*, which is low, by changing *V* into *B*, because it holdeth the lower part of the Song.

Of the higher Tenor.

THe high *Tenor*, is the vppermost part, saue one of a Song: or it is the grace of the *Base*: for most commonly it graceth the *Base*, making a double *Concord* with it. The other parts euery Student may describe by himselfe.

Of the formall Closes.

BEing that euery Song is graced with formall *Closes*, we will tell what a *Close* is. Wherfore a *Close* is (as *Tinctor* writes) a little part of a Song, in whose end is found either rest or perfection. Or it is the coniunction of voices (going diuersly) in perfect *Concords*.

Rules for Closes.

FIrst, Euery *Close* consists of three Notes, the last, the last saue one, and the last saue two.

2 The *Close* of the *Discantus* made with three Notes, shall alwayes haue the last vpward.

3 The *Close* of the *Tenor*, doth also consist of three Notes, the last alwayes descending.

4 The *Close* of the *base* requires the last Note sometime aboue, and sometime beneath the *Tenor*. Yet commonly it thrusts it an eight below, and sometimes raiseth it a fift aboue.

5 The *Close* of a high *Tenor*, doth sometime rise, sometime fall with the last Note: sometime makes it an Vnison with others, Which being it proceeds by diuers motions, the sorting of it is at the pleasure of the Composers.

6 The *Close* of the *Discantus*, doth require the last Note saue one aboue the *Tenor* in a sixt : or in a fift, if the *Base* hold a sixt below.

7 The last Note saue one of a *Tenor*, is flatly placed a fift aboue the *Base*, and a sixt also, if the *Base* take the *Close* of the *Tenor*, and the *Tenor* the *Close* of the *Discantus*.

8 If the *Close* of the *Tenor* end in *Mi*, as it is in the *Deutero*, or otherwise the last Note but one of the *base* being placed not in the fift. But in the third beneath

beneath the *Tenor*, may fall vpon the fift Finall without any hazard of
Descant, as is declared in the vnder-written *Consent*.

Tenor. *Bassus.*

9 If the *Close* of the *Tenor* end in *Re*, as commonly it doth in the first
Tone, the *Base* shall very finely end from a fift to a third vpward, not varying
the *Discantus*, although it may also fall into an eight.

Tenor. *Bassus.*

10 Euery Song is so much the sweeter, by how much the fuller it is of
formall *Closes*. For such force there is in *Closes*, that it maketh *Discords* be-
come *Concords* for perfection sake. Therefore let Students labour to fill their
Songs with formall *Closes*. Now that they may the more easily doe this, we
thought fit here to set downe an Exercise or Store-house of *Closes*, that such
as Students sing here, they may know they are in their owne Songs to make.

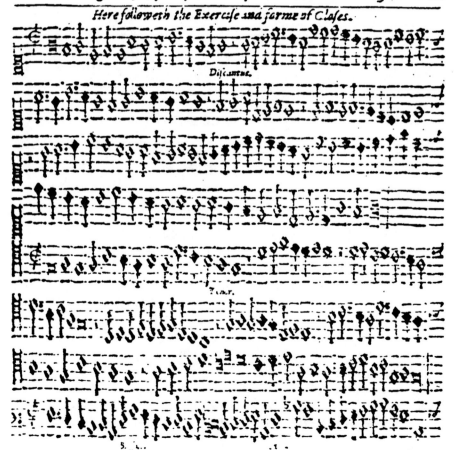

Here followeth the Exercise and forme of Closes.

Discantus.

Tenor.

THE SIXT CHAPTER.

Of the speciall precepts of the Counter-point.

Auing deliuered those things which we thinke necessarie for the Art of setting, now will we in most short Rules open essentially the matter it selfe, as it is.

1 The *Cantus* being ordered with a *Tenor* in an Vnison, the *Base* requires a third below, and the *Altus* the same aboue. Or the *Base* a fift below, and the *Altus* a fourth aboue. But if the *Base* hold an eight below, the *Altus* shall agree most fitly in a third aboue, or in a fourth below. But if the *Base* hold a tenth below, the *Altus* requires a third aboue, or the same, or a sixt below, as you may see in the figure following.

2 As oft as the *Discantus* is placed a 3. aboue the *Tenor*, let the *Base* be placed a third below, and the *Altus* a sixt aboue, or in an Vnison. But if the *Base* haue an eight below, for a fift it cannot haue, the *Altus* shall hold a fourth below. But if the *Base* hold a tenth below, the *Altus* requires a third, or a sixt below. Which a Student may proue by such a Scale as goes before.

3 If the *Discantus* hold place in a fift aboue the *Tenor*, which it seldome doth, the *Base* shall be in a sixt below, and the *Altus* in a third aboue, or in a fourth below. But if the *Base* be in an eight below, the *Altus* requires a third aboue, or a fourth, or a sixt below.

4 If the *Discantus* be in a sixt aboue the *Tenor*, the *Base* shalbe in a fift below, and the *Altus* in a third below, or a fourth aboue. Or if the *Base* be in an eight below, the *Altus* shall onely agree in a third aboue; but when the

Bafe is in a tenth below, the *Altus* fhalbe in a third aboue, or in the fame below. It might alfo be in an eight below, and found a thirteenth with the *Difcantus.*

5 If the *Difcantus* be placed in an eight aboue the *Tenor,* the *Bafe* will agree well in a third below, & the *Altus* in a third or fixt aboue, or in a fift below. But when a *Bafe* be in the fame below, the *Altus* fhalbe in a fourth or fixt aboue, or in a third below. If the *Bafe* be in an eight below, the *Altus* fhall fweetly agree in a fift or third aboue. But if the *Bafe* fall to a tenth below, the *Altus* fhall hold a third or fixt aboue, or the fame below.

6 As oft as the *Difcantus* doth reft in a tenth aboue the *Tenor* : the *Bafe* fhall be in a third below, and the *Altus* in a third, fixt, or eight aboue. But if the *Bafe* be found in a third aboue, the *Altus* fhalbe in a third below, or in a fift or eight aboue. But if the *Bafe* be in a fift aboue the *Tenor,* (for below it cannot) the *Altus* fhalbe in a third aboue, or an eight below. But if the *Bafe* fall to an eight below, the *Altus* may be in a fourth below, or in a third or fift aboue.

7 When the *Difcantus* is in a twelfe aboue the *Tenor,* the *Bafe* muft be in an eight below, & the *Altus* in a third, fift, or eight aboue. But when the *Bafe* is in a third aboue, the *Altus* fhall be in a fift, eight, or tenth concordantly.

8 If the *Difcantus* be in a fourth aboue the *Tenor,* the *Bafe* requires a a fift below, & the *Altus* a third or fixt aboue. Contrarily (if you make your *Bafe* firft) you fhall make it with the *Difcantus.* But if a man will make more than 4. parts, let him take the *Concords* aboue or below, as other parts fhall require, obferuing thofe things which are to be obferued, which we referre to the Setters iudgement.

THE SEVENTH CHAPTER.

Wherefore Refts are put in the Counter-point.

He placing of *Refts* in a *Counterpoint,* is for many caufes tollerated.

1 To auoide difficulty. For whilft two parts of a fong or more are fo fitted together that it is hard to fit the other parts, we fet *Refts* for fo long, till that difficultie ceafe.

2 To auoide *Fift* Voices, and the forbidden Interuals.

3 To diftinguifh two perfect *Concords* which cannot mutually follow one another, vnleffe a Note or paufe come betwixt.

4 For the making of *Signes.* Now a figne is the fucceffiue diftribution of one and the fame Clofe, in the beginning or any other place, by diuers parts of a Song. Or it is the repetition of the fame Clofe in diuers parts of the fong thus :

Difcantus. *Tenor.* *Baffus.*

5 *Rests* are admitted for taking breath, least by the swiftnesse of the Song, either the Singer might be out of breath, or breed confusion by taking his breath at vnfit times.

6 That the *Intrinsecall* signes and markes of Musicall degrees, consisting in their perfection, may be perceiued. For a perfect *Mood* is inwardly noted by a rest of 3.times. A perfect time by 2.*Semibreefe* Rests, placed with a *Semibreefe*, as before is said in the fift Chapter of the second booke.

7 Because of the many parts of a song. For when a song goes with more parts than foure, it is necessary that some Rest, whilst others sing : least the sweetnesse be dulled either by the too much prolonging of the Voices, or by the vnelegant commixtion of *Concords*, and so the Consort seeme rather to make a noyse, then a Concordant sound.

The Eight Chapter.

Of the diuers fashions of singing, and of the Ten Precepts for Singing.

Very man liues after his owne humour; neither are all men gouerned by the same lawes, and diuers Nations haue diuers fashions, and differ in habite, diet, studies, speech, and song. Hence is it, that the English doe carroll; the French sing; the Spaniards weepe; the Italians, which dwell about the Coasts of *Ianua* caper with their Voyces; the other barke : but the Germanes (which I am ashamed to vtter) doe howle like Wolues. Now because it is better to breake friendship, than to determine any thing against truth, I am forced by truth to say that which the loue of my Countrey forbids me to publish. *Germany* nourisheth many Cantors, but few Musitians. For very few, excepting those which are or haue been in the Chappels of Princes, doe truely know the Att of Singing. For those Magistrates to whom this charge is giuen, doe appoint for the gouernment of the Seruice youth Cantors, whom they choose by the shrilnesse of their Voyce, not for their cunning in the Art; thinking that God is pleased with bellowing and braying, of whom we read in the Scripture, that he reioyceth more in sweetnes than in noyse, more in the affection, than in the Voice. For whē *Salomon* in the *Canticles* writeth, that the voice of the church doth sound in the eares of Christ, hee doth presently adioyne the cause, because it is sweet. Therefore well did *Baptista Mantuan* (that moderne *Virgil*) inueigh euery puffed vp, ignorant, bellowing Cantor, saying;

Cur tantis delubra Boum mugitibus imples,
Tu ne Deum tali credis placare tumultu.

Whom the Prophet ordained should be praised in Cymbals, not simply, but well sounding.

Of the Ten Precepts necessary for euery Singer.

BEing that diuers men doe diuersly abuse themselues in Gods praise; some by mouing their body vndecently; some by gaping vnseemely; some by changing the vowels, I thought good to teach all Cantors certaine Precepts, by which they may erre lesse.

1 When

1 When you defire to fing any thing, aboue all things marke the *Tone*, and his *Repercuſsion*. For he that fings a Song without knowing the *Tone*, doth like him that makes a ſyllogiſme without *Moode* and Figure.

2 Let him diligently marke the *Scale*, vnder which the Song runneth, leaſt he make a *Flat* of a *Sharpe* or a *Sharpe* of a *Flat*.

3 Let euery Singer conforme his voyce to the words, that as much as he can he make the *Concent* ſad when the words are ſad;& merry,when they are merry Wherein I cannot but wonder at the Saxons (the moſt galliant people of all Germany, by whoſe furtherance I was both brought vp, and drawne to write of Muſicke) in that they vſe in their funerals,an high,merry and ioconde *Concent*, for no other cauſe (I thinke) than that either they hold death to be the greateſt good that can befall a man (as *Valerius* in his fiſt Booke writes of *Cleobis* and *Biton* two brothers) or in that they beleeue that the ſoules (as it is in *Macrobius* his ſecond Booke *De ſomnio Scip.*) after this body doe returne to the original ſweetnes of Muſicke,that is to heauen. Which if it be the cauſe,we may iudge them to be valiant in contemning death,and worthy deſirers of the glory to come.

4 Aboue all things keepe the equalitie of meaſure. For to ſing without law and meaſure,is an offence to God himſelfe, who hath made all things well,in number,weight,and meaſure.Wherefore I would haue the Faſterly *Franci*(my countrey-men)to follow the beſt manner,and not as before they haue done;ſometime long;ſometime to make ſhort the Notes in Plain-ſong, but take example of the noble Church of *Herbipolis*,their head,wherin they ſing excellently.Which would alſo much profit,and honour the Church of *Prage*,becauſe in it alſo they make the Notes ſometimes longer,ſometime ſhorter, than they ſhould Neither muſt this be omitted, which that loue which we owe to the dead,doth require. Whoſe *Vigils* (for ſo are they commonly called)are performed with ſuch confuſion,haſt,and mockery,(I know not what fury poſſeſſeth the mindes of thoſe, to whom this charge is put ouer)that neither one Voyce can be diſtinguiſhed from another, nor one ſillable from another, nor one verſe ſometimes throughout a whole Pſalme from another.An impious faſhion to be puniſhed with the ſeuereſt correction.Think you that God is pleaſed with ſuch howling ſuch noiſe,ſuch mumbling in which is no deuotion, no expreſſing of words, no articulating of ſyllables ?

5 The Songs of Authenticall *Tones* muſt be timed deepe, of the ſubiugall *Tons* high,of the neutrall,meanly.For theſe goe deep,thoſe high, the other both high and low.

6 The changing of Vowels is a ſigne of an vnlearned Singer. Now, (though diuers people doe diuerſly offend in this kinde) yet doth not the multitude of offenders take away the fault. Here I would haue the *Francks* to take heede they pronounce not *u* for *o*, as they are wont, ſaying *nuſter* for *noſter*.The countrey Church-men are alſo to be cenſured for pronouncing,*Aremus* in ſtead of *Oremus*. In like ſort, doe all the *Renenſes* from *Spyre*

to *Confluentia* change the Vowel *i* into the dipthong *ei*, saying *Mareia* for *Maria*. The *Westphalians* for the vowel *a* pronounce *a* & *e* together, to wit, *Aebs-te* for *Abste*. The lower Saxons, & al the *Sueuians*, for the Vowel *e*, read *e* & *i*, saying, *Deius* for *Deus*. They of lower *Germany* doe all expresse *u* & *e*, in stead of the Vowel *u*. Which errours, though the *Germane* speech doe often require, yet doth the Latine tongue, which hath the affinitie with ours, exceedingly abhorre them.

7 Let a Singer take heed, least he begin too loud braying like an Asse, or when he hath begun with an vneuen height, disgrace the Song. For God is not pleased with loude cryes, but with louely sounds: it is not (saith our *Erasmus*) the noyse of the lips, but the ardent desire of the Art, which like the lowdest voice doth pierce Gods eares. *Moses* spake not, yet heard these words, *Why doest thou cry vnto me?* But why the Saxons, and those that dwell vpon the Balticke coast, should so delight in such clamouring, there is no reason, but either because they haue a deafe God, or because they thinke he is gone to the South-side of heauen, and therefore cannot so easily heare both the Easterlings, and the Southerlings.

8 Let euery Singer discerne the difference of one holiday from another, least on a sleight Holiday, he either make too solemne seruice, or too sleight on a great.

9 The vncomely gaping of the mouth, and vngracefull motion of the body, is a signe of a mad Singer.

10 Aboue all things, let the Singer study to please God, and not men; (saith *Guido*) there are foolish Singers, who contemne the deuotion they should seeke after, and affect the wantonnesse which they should shun: because they intend their singing to men, not to God: seeking for a little worldly fame, that so they may loose the eternall glory: pleasing men that thereby they may displease God: imparting to other that deuotion, which themselues want: seeking the fauour of the creature, contemning the loue of the Creatour: to whom is due all honour, and reuerence, and seruice. To whom I doe deuote my selfe, and all that is mine, to him will I sing as long as I haue being: for he hath raised me (poore Wretch) from the earth, and from the meanest basenesse. Therefore blessed be his Name world without end, *Amen.*

The end of the Worke.

The Epilogue and Conclusion of the Booke.

Am to intreat the curteous Reader fauourably to view this Worke of Mufical Theorems, which I haue before this fome yeres paft fearched out, & now at laft put into the forme of a booke and printed, not out of any arrogant humour, as fome enuious perfons wil report, but out of a defire to profit the Youth of Germany, whilst others are drousie. If the bafenes of the ftile, or fimplenes of the words offend any man, I intreat him to attribute that to the matter which we handle, and the perfons for whom it is written, namely, Children. I doubt not but there will be fome, that will be foone ready to fnarle at it, and to backbite it, contemning it before they read it, and difgracing it before they vnderftand it. Who had rather feeme than be Mufitians, not obeying Authors, or Precepts, or Reafons: but whatfoeuer comes into their hairebraind Cockfcombe, accounting that onely lawful, artificiall, and Muficall. To whom I intreat you (gentle Readers) to lend no eare. For it is a thing praife-worthy to difpleafe the euill. Yea, (to vfe the fentence of Antifthenes the Philofopher) to be backbited is a figne of greatneffe; to backebite, a token of meaneffe. And becaufe the praife of one wife man is better than the commendation of Ten fooles; I pray confider not the number, but the quality of thofe detractors: and thinke what an eefie matter it is to filence thofe Pyes, and to crufh fuch Fleas euen betwixt two nayles. Neither earken ye to thofe that hate the Art: for they diffuade others from that which their dulneffe will not fuffer them to attaine to, for in vaine it is to harpe before an Affe. But accounct that this I fpeake to you as a Mafter, becaufe I haue paffed the Ferrular. For the cunning men in each Art muft be beleeued, as the Emperours Maieftie faith. Wherefore let thofe courteous Readers (that be delighted with Ornithoparchus his paines taken) be contented with thefe few things, for as foone as I can but take breath, they fhall fee matters of greater worth.

A TABLE OF ALL THAT IS CONTAINED IN THE FIRST BOOKE.

The Table of all that is contained in the second Booke.

The Table of all that is contained in the Third Booke.

The Table of all that is contained in the Fourth Booke.

FINIS.

CPSIA information can be obtained at www.ICGtesting.com
Printed in the USA
LVOW051649281111

256815LV00010B/37/P